EARLY AND FIRST GENERATION
GREEN DIESELS
IN PHOTOGRAPHS

BRIAN J. DICKSON

The
History
Press

ACKNOWLEDGEMENTS

Grateful thanks are due to Driver Rob Fraser for his assistance with the details of preserved diesel locomotives, and to Driver John Webb for sharing his route knowledge of the former Great Northern line from London Kings Cross to Hitchin.

The photographs in this work are from the archive held by Initial Photographics. A complete catalogue can be sourced by writing to 25 The Limes, Stony Stratford, MK11 1ET.

Front Cover: At St Pancras station in London, it is 6.25 p.m. on a July evening in 1965 and Derby Works-constructed Type 2 (Class 25) No. D5292 is preparing to depart at the head of a parcel train. Entering service during 1964, it would become No. 25 142 in the TOPS scheme and be withdrawn in 1981. (Andrew Forsyth)

Back Cover: Saturday, 20 July 1963. Working a 'down' passenger train, BRC&W Type 2 (Class 27) No. D5361 is seen at Stirling station. Entering service in 1961 and allocated to Glasgow Eastfield for its entire working life, it would become No. 27 015 under TOPS and be withdrawn from service during 1977. (Andrew Forsyth)

First published 2020

The History Press
97 St George's Place, Cheltenham,
Gloucestershire, GL50 3QB
www.thehistorypress.co.uk

British Library Cataloguing in Publication Data.
A catalogue record for this book is available from the British Library.

ISBN 978 0 7509 9265 7

Typesetting and origination by The History Press
Printed in Turkey by Imak

INTRODUCTION

The London Midland and Scottish Railway (LMS), the Great Western Railway (GWR), the Southern Railway (SR) and the London and North Eastern Railway (LNER) – the 'Big Four' as they became known – had experimented with the purchase and production of diesel shunters from as early as 1933, when the GWR purchased an 0-4-0 diesel mechanical locomotive from John Fowler & Co. of Leeds. They also purchased an 0-6-0 diesel electric shunter during 1936 from R. & W. Hawthorn Leslie & Co., which was followed in 1948 by Swindon Works constructing seven further examples, six of which utilised English Electric diesel engines, the other a Brush engine.

The LMS had likewise purchased an 0-6-0 diesel mechanical locomotive during 1933 from the Hunslet Engine Co., which was followed in 1934 and 1935 by five further locomotives from Hunslet, Hudswell Clarke and Harland & Wolfe, all using diesel mechanical transmission. A sixth locomotive was purchased from Armstrong Whitworth in 1934 that utilised diesel electric transmission. In addition, during 1934 and 1935 the LMS purchased eleven further diesel electric 0-6-0 shunters from English Electric Ltd, and these were followed in 1936 by a further ten examples from Armstrong Whitworth that used diesel electric transmission delivered through a 'jackshaft' drive. This last batch turned out to be such reliable machines that a further forty examples were constructed by the LMS at Derby Works between 1939 and 1942, all utilising English Electric equipment and the jackshaft drive. Construction continued from 1945 until after nationalisation in 1952, with a further seventy locomotives entering service from Derby Works that used diesel electric drive directly to the traction wheels. Another thirty-six examples were also manufactured at the ex-LNER works at Darlington during 1952 and 1953.

The SR had constructed three 0-6-0 diesel electric shunters at its Ashford Works during 1937 using English Electric equipment, but it wasn't until after nationalisation that construction of a further twenty-six examples took place, all coming from the ex-SR works at Ashford between 1949 and 1952.

Coming late to the acquisition of diesel traction, it was 1944 before the LNER constructed four examples of an 0-6-0 diesel electric shunter. Entering service from Doncaster Works during 1944 and 1945 and utilising English Electric engines and equipment, they spent the bulk of their lives working in Whitemoor yard at March. One further example was constructed during 1946 at Doncaster, the frame and bodywork being transferred to The Brush Falcon Works at Loughborough for the engine and electrical equipment to be fitted.

Post-nationalisation, the 350hp 0-6-0 diesel electric shunter design was continued by British Railways (BR), using the LMS design from 1945 as the prototype. A total of 996 examples were constructed over a period of eleven years between 1952 and 1962 at five sites: Crewe, Darlington, Derby, Doncaster and Horwich Works. They were to be seen all over the BR network handling station pilot duties, yard shunting and short trip goods work. Under the 1972 Total Operations Processing System (TOPS) scheme they became Class 08 and a large number are still in use with main-line operators, private contractors and heritage railways.

Although the GWR had not greatly pursued diesel traction for shunting locomotives, it took great interest in its use for passenger vehicles. During 1933 the Associated Equipment Company Ltd (AEC) and its associate Park Royal Coachworks had produced a beautifully streamlined art deco-style railcar powered by one diesel engine. Purchased by the GWR and numbered 1 by them, it commenced services in the Reading area during December of that year. Following the success of this introduction, a further batch of three vehicles, numbered 2 to 4, followed during 1934, again constructed by the AEC group but this time incorporating two diesel engines. These were followed by a further thirteen railcars during 1935 and 1936 constructed by the Gloucester Railway Carriage and Wagon Co. (GRC&W), utilising the same basic design as the first four. These were numbered 5 to 17, the last being constructed as a parcels-only car. One further car, No. 18, appeared in 1937 from AEC, with its outward appearance varying slightly from the original art deco streamlined lines. This car was fitted with conventional buffers and draw gear that enabled a trailing vehicle to be hauled. It would be 1940 before any more railcars were constructed, with Nos 19 to 28 entering service during that year. During 1941 Nos 29 to 36 appeared, with No. 34 being constructed as another parcels van; finally, Nos 37 and 38 entered service the following year. These final twenty railcars were all constructed at Swindon Works using AEC engines, fitted with buffers and draw gear and with their body work losing the earlier art deco styling to look more functional.

The 1955 British Transport Commission plan for the 'Modernisation and Re-Equipment of British Railways' was published at a time when the only large main-line diesels operating on BR were the two LMS-designed Co-Cos (Nos 10000/1); the Fell 4-8-4 locomotive (No. 10100); the three Southern Region 1Co-Co1s (Nos 10201–3); and the LMS-designed Bo-Bo (No. 10800), built by the North British Locomotive Co. (NBL). In locomotive terms, the Modernisation Plan predicted the end of steam traction by announcing that no new steam locomotives would be built after the end of the 1956 programme. Although electrification was the ultimate goal, diesel traction, particularly with electric transmission, was seen as the way forward, and an initial programme (the Pilot Scheme) was devised, wherein 174 main-line diesel locomotives would be purchased from various manufacturers – 160 with electric transmission and 14 with hydraulic transmission specifically for the Western Region. These were to be in three power groups:

Type A	600–1000hp
Type B	1000–1250hp
Type C	2000hp and over

These three groups later became five:

Type 1	1000hp or less
Type 2	1000–1500hp
Type 3	1500–2000hp
Type 4	2000–3000hp
Type 5	3000hp and over

The initial orders fell into the groups shown in the table below:

Type	TOPS Class	Builder	Engine Power	Wheel Arr	Transmission	Initial Order	Delivered	Number Series
1	15	Clayton*	800hp	Bo-Bo	Electric	10	1957>	D8200>
1	16	NBL	800hp	Bo-Bo	Electric	10	1958>	D8400>
1	20	English Electric	1000hp	Bo-Bo	Electric	20	1957>	D8000>
2	21	NBL	1000hp	Bo-Bo	Electric	10	1958>	D6100>
2	22	NBL	1000hp	B-B	Hydraulic	6	1958>	D6300>
2	23	English Electric	1100hp	Bo-Bo	Electric	10	1959>	D5900>
2	24	BR Derby	1160hp	Bo-Bo	Electric	20	1958>	D5000>
2	26	BRC&W	1160hp	Bo-Bo	Electric	20	1958>	D5300>
2	28	Metro-Vickers	1200hp	Co-Bo	Electric	20	1958>	D5700>
2	30	Brush	1250hp	A1A-A1A	Electric	20	1957>	D5500>
4	40	English Electric	2000hp	1Co-Co1	Electric	10	1958>	D200>
4	41	NBL	2000hp	A1A-A1A	Hydraulic	5	1957>	D600>
4	42	BR Swindon	2000hp	B-B	Hydraulic	3	1958>	D800>
4	44	BR Derby	2300hp	1Co-Co1	Electric	10	1959>	D1>

* construction sub-contracted to Yorkshire Engine Co.

The intention was that, as the various types of Pilot Scheme locomotives were delivered, they would undergo intensive evaluation trials, but the policy soon changed to one wherein these locomotives were put into revenue-earning service as quickly as possible. To hasten the demise of steam, many manufacturing orders were increased before completion and testing of the initial orders. Hence such types as the NBL/MAN Type 2 (Class 21) – although it was quickly recognised as having a troublesome engine, it reached a final build total of fifty-eight locomotives.

The numbering for these new diesel locomotives had been agreed in 1957, prior to their introduction, with the use of a four-digit number and a 'D' prefix. Diesel shunters built prior to 1957 that bore five digits were allocated a new number with a 'D' prefix. In September 1968, when the age of standard-gauge steam traction on BR ended, the use of the 'D' prefix was discontinued. In practice locomotives started to lose the 'D' prefix either when they went into workshops for overhaul or when individual depots started to paint out the 'D'; either way, a large number of locomotives kept the 'D' prefix for many years. In 1972, the present TOPS scheme was introduced, locomotives being allocated a two-digit class number followed by an individual serial number: for example, English Electric Type 1 (Class 20) No. D8031 became 20 8031.

It would be June 1957 before the first examples of the Pilot Scheme locomotives commenced delivery from their manufacturers. English Electric Type 1's (Class 20) were despatched from their works at the Vulcan Foundry and arrived at Devons Road shed in Bow, London; these were followed in October by Brush Traction-built Type 2s (Class 30) at Stratford depot in East London, and then Clayton-constructed Type 1s (Class 15) at Devons Road in November.

The first twenty examples of the Brush Traction Type 2 (Class 30) were constructed using a Mirrlees twelve-cylinder 1250hp-rated engine, while the remaining 243 locomotives used a Mirrlees 1350hp-rated engine. However, these engines proved to be troublesome and all locomotives in the class were rebuilt between 1964 and 1969 to use the more reliable English Electric twelve-cylinder 1470hp-rated engine. The whole class was subsequently reclassified Class 31.

There was a rush of deliveries for further Pilot Scheme locomotives in 1958, with NBL-constructed Type 4 (Class 41) Hydraulics arriving at Swindon during January, English Electric Type 4 (Class 40) reaching Stratford shed in March and NBL-built Type 1 (Class 16) locomotives being delivered to Devons Road shed in May. Meanwhile, July saw examples of the Sulzer-engined Birmingham Railway Carriage and Wagon Co.'s (BRC&W) Type 2 (Class 26) arriving at Hornsey shed, and Metropolitan Vickers-constructed Type 2s (Class 28) with Crossley two-stroke diesel engines delivered to Derby. August saw NBL-manufactured Type 4 (Class 42) Hydraulics arriving at Plymouth Laira, while Crew South shed was the recipient of the first members of the BR Derby Works-constructed Type 2s (Class 24), which utilised Sulzer engines. Finally, in December, Hornsey shed saw delivery of NBL-constructed Type 2 (Class 21) locomotives.

The Hydraulics of the NBL-constructed Type 2 (Class 22) started delivery from Glasgow to Swindon during January 1959, but it wouldn't be until May that examples of the English Electric Type 2 (Class 23) commenced delivery to Hornsey depot. The final example of the Pilot Scheme locomotive types to be delivered in 1959 were

the BR Derby Works-constructed and Sulzer-engined Type 4s (Class 44), which arrived in Camden shed in August.

The reliability of some of these types was called into question very quickly, with NBL-constructed locomotives utilising MAN engines being of particular concern. Their Type 2 (Class 21) were hurriedly reallocated to Scottish depots so they would be close to their manufacturer while remedial work was carried out. The English Electric Type 2 (Class 23) also proved to be troublesome, with all ten examples having a very short working life. Fortunately, the English Electric-built Type 1 and 4 (Classes 20 and 40) proved to be highly successful and reliable locomotives; similarly, the Sulzer-engined Type 2's (Classes 24 and 26), from Derby Works and the BRC&W, also turned out to be reliable performers. The Derby Works-constructed, Sulzer-engined Type 4 (Class 44), which became known as 'Peaks', also proved themselves to be very competent workhorses.

Further locomotives of Types 1, 2, 4 and a new Type 3 and Type 5 were ordered after the completion of the Pilot Scheme, with the first delivered being the English Electric Type 3 (Class 37), which arrived at Stratford depot in December 1960. In February 1961, the first of the English Electric Type 5 (Class 55) 'Deltics' were delivered to Haymarket and Finsbury Park depots. Based on the experimental locomotive DP1, which had been tested with BR from late 1955, a total of twenty-two were ordered to replace steam traction, working express passenger traffic on the East Coast Main Line. Allocated to Haymarket in Edinburgh, Gateshead in Tyne and Wear, and Finsbury Park in London, they were very quickly handling all the major express passenger trains on the route, earning their keep for nearly twenty years before being replaced by InterCity 125 High Speed Trains. During September 1962 the Clayton Equipment Co. Type 1 (Class 17) locomotives were delivered to Scottish Region depots – the Type 1s were a versatile design with two Paxman engines, one or both of which could be used depending on the load. Unfortunately, it soon became apparent that these engines were developing major technical problems, so all were rapidly phased out of service. Also delivered during September were the first of what became one of the most reliable and versatile diesel electric locomotive types: the Brush Traction-constructed Type 4 (Class 47). It utilised a Sulzer engine and construction reached a total of 512 examples, 310 from Brush in Loughborough and 202 from Crewe Works.

The photographs in this book have been selected from the archive of negatives held by Initial Photographics. They are the work of four photographers – Ron Buckley, Robert Butterfield, Andrew Forsyth and Hugh Ramsay – and cover the period from 1949 until 1966, showing the progression from diesel shunting locomotives and early main line diesels to the BR Pilot Scheme's successes and failures. A number of the earliest deliveries of the Pilot Scheme locomotives were fitted with folding disc indicators in addition to conventional lamp brackets, but later examples saw the appearance of four-digit roller blinds so that the train's reporting numbers could be displayed. This reporting system was introduced by BR during 1960 and continued until 1976, when power signalling and train control systems replaced the need for route indicators.

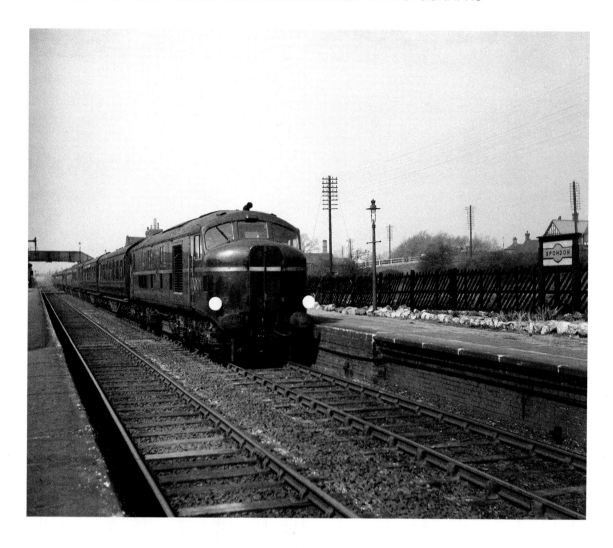

Above: **Saturday, 16 April 1949**. No. 10001 is seen at speed passing Spondon station at the head of the 12.05 p.m. Derby to London St Pancras express. It would be withdrawn during 1966. (Ron Buckley)

Opposite: **Tuesday, 3 May 1949**. Departing Derby station at the head of a special test train to Leicester is No. 10000, in splendid condition sporting her former LMS identity. It would be withdrawn from service during 1963. (Ron Buckley)

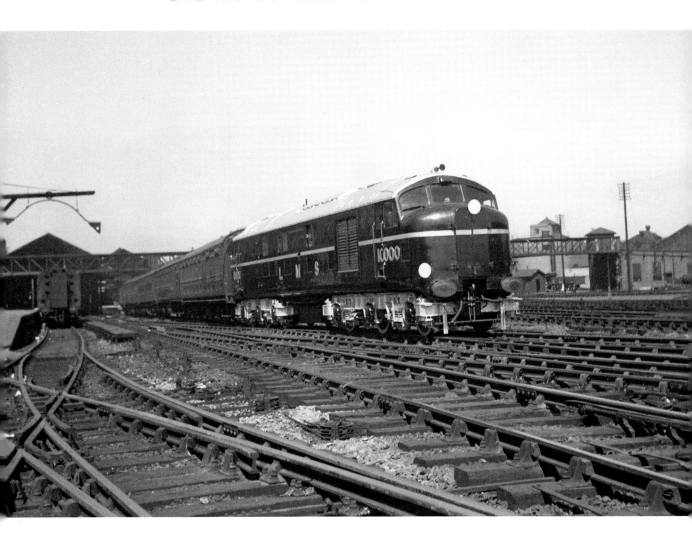

Constructed as a co-operation between the LMS and English Electric, Nos 10000 and 10001 were the first main-line diesel electric locomotives in Great Britain. Construction began at Derby Works in 1946, with the first example, No. 10000, entering service during December 1947. Utilising the English Electric sixteen-cylinder four-stroke diesel engine, rated at 1600hp, the first locomotive appeared proudly bearing the LMS identity in large cast aluminium-alloy lettering on its bodywork. No. 10000's revenue-earning service commenced between St Pancras and Derby, with some longer runs to Manchester, but after the appearance of sister No. 10001 during July 1948, both locomotives were allocated to Camden shed and utilised on the Euston to Carlisle route. During the later 1950s both locomotives working in tandem could be seen hauling the 'Royal Scot'.

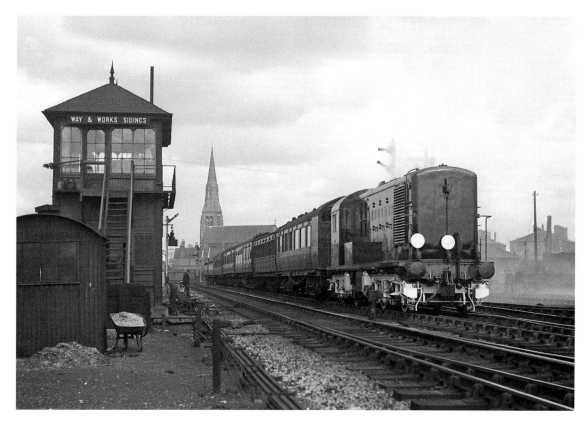

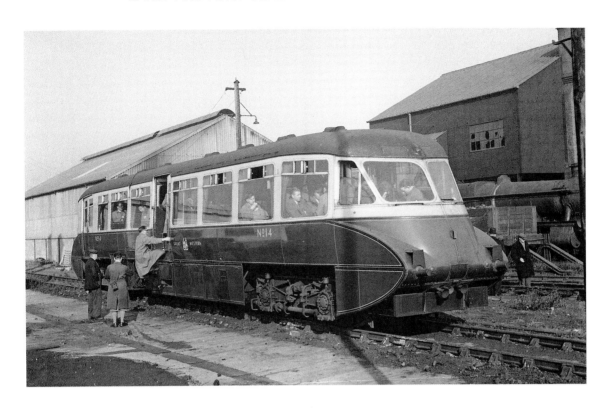

Opposite top: **Friday, 16 September 1949**. This busy scene is at Monmouth Troy station with ex-GWR Railcar No. 23 (right) waiting to depart with the 9.10 a.m. working to Chepstow, and ex-GWR Railcar No. 30 (left) waiting to depart with the 9.10 a.m. working to Pontypool Road. Both were constructed by Swindon Works, No. 23 during 1940 and No. 30 in 1941, and both would be withdrawn from service in 1962. The Pontypool Road passenger service would be withdrawn during June 1955, but the Chepstow passenger service wouldn't be withdrawn until January 1959. Monmouth Troy station itself would finally close to passengers during January 1964. (Ron Buckley)

Opposite bottom: **Thursday, 22 June 1950**. Having been ordered by the LMS in 1946 from the NBL in Glasgow, No. 10800 would not be delivered to Derby Works until 1950. It spent time undergoing tests with the Southern Region, Eastern Region and London Midland Region before being withdrawn during 1959. Bought by Brush Traction in 1962, it then became a test bed locomotive, fitted with a new diesel engine and electronic equipment. Unofficially named *Hawk*, it underwent further testing at the BR plant at Rugby, before finally being withdrawn in 1968 and later scrapped. It is seen here passing the Way & Works Sidings signal box in Derby at the head of a test train to Trent, comprising a very mixed rake of carriages. (Ron Buckley)

Above: **Sunday, 29 October 1950**. Enthusiasts are boarding ex-GWR Railcar No. 14 after a visit to Banbury depot yard. Still bearing its Great Western livery and identity, it was a product of the GRC&W during 1936, and would give twenty-four years of service before being withdrawn in 1960. (Ron Buckley)

The large diesel mechanical locomotive No. 10100 (also known as the 'Fell' locomotive) came out of Derby Works in late 1950 and spent much of her life undergoing tests. A 4-8-4 wheel arrangement, it was constructed with four Davey Paxman 500hp twelve-cylinder engines and connected mechanically to the eight linked drive wheels. It saw some revenue-earning service throughout its short life, but it was withdrawn during 1958.

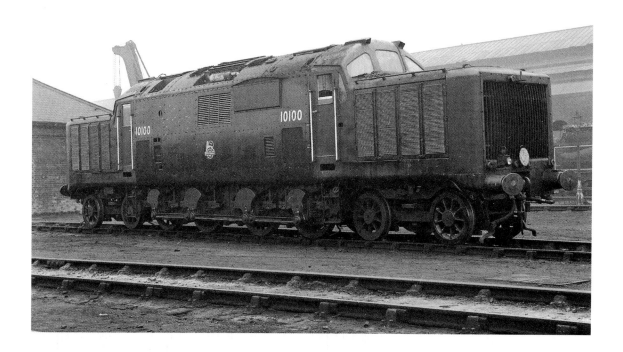

Above: **Friday, 25 January 1952**. No. 10100 is standing in Derby Works yard. (Ron Buckley)

Opposite: **Monday, 10 March 1952**. No. 10100 is receiving much attention at Derby station whilst waiting to depart at the head of its first revenue-earning run, the 12.05 p.m. service to London St Pancras. (Ron Buckley)

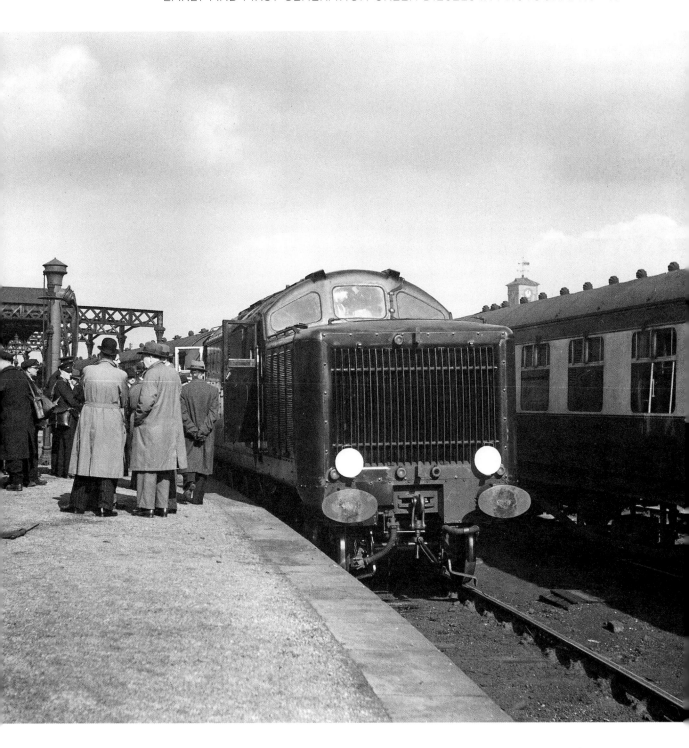

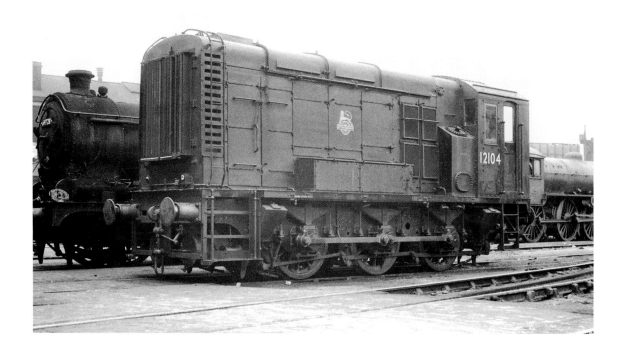

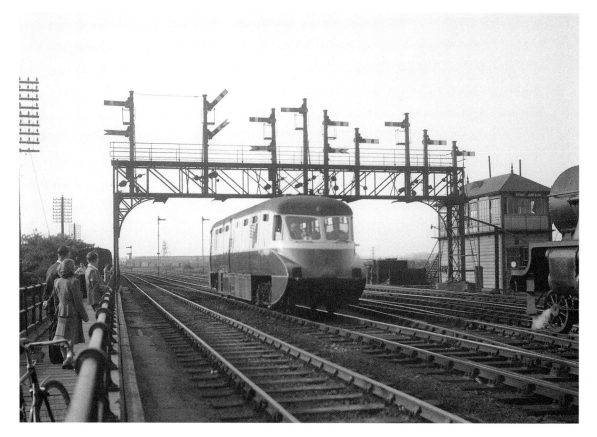

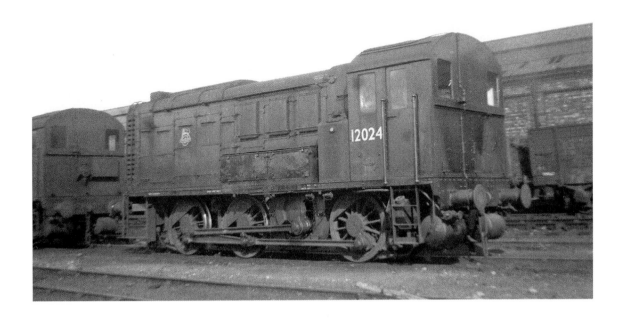

Opposite top: **Saturday, 7 June 1952**. The LMS-designed 0-6-0 diesel electric shunter No. 12104 was constructed post-nationalisation at Darlington Works during 1952. It is seen here at barely two months old at Stratford depot, where it would be based for much of its working life. It would only give fifteen years of service before being withdrawn in 1967. (Andrew Forsyth)

Opposite bottom: **Saturday, 28 June 1952**. Seen passing Derby Junction 'box on the northern approach to Derby station, ex-GWR Railcar No. W14 is operating the 6.05pm returning special from Buxton to Solihull. (Ron Buckley)

Above: **October 1952**. Ex-LMS 0-6-0 diesel electric shunter No. 12024 stands in the yard at Carlisle Upperby shed. Originally numbered 7111 by the LMS, it was constructed at Derby Works in 1942 using English Electric equipment – the jackshaft drive is clearly visible. It would continue in service for twenty-five years until it was withdrawn in 1967. (Robert Butterfield)

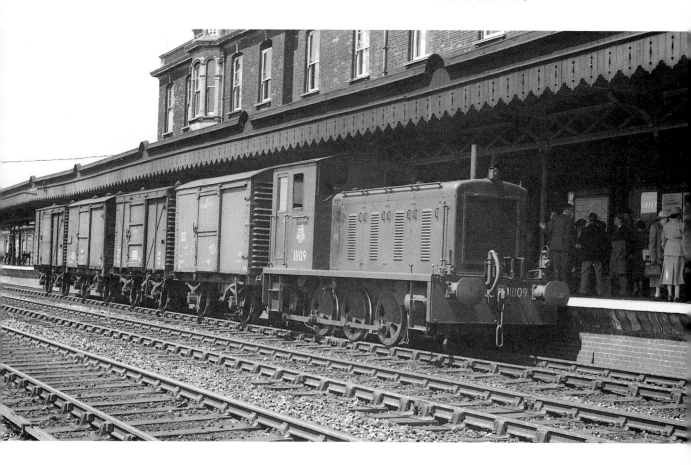

Saturday, 25 July 1953. Pictured at Harwich station, this 0-6-0 diesel mechanical shunter attached to four vans was purchased by BR from the Drewry Car Co. in 1953. Class 04 No. 11109 would be renumbered D2208 and be withdrawn from service during 1968. Sold to the National Coal Board, it would find use at the Silverwood colliery in Yorkshire and be scrapped there in 1978. (Andrew Forsyth)

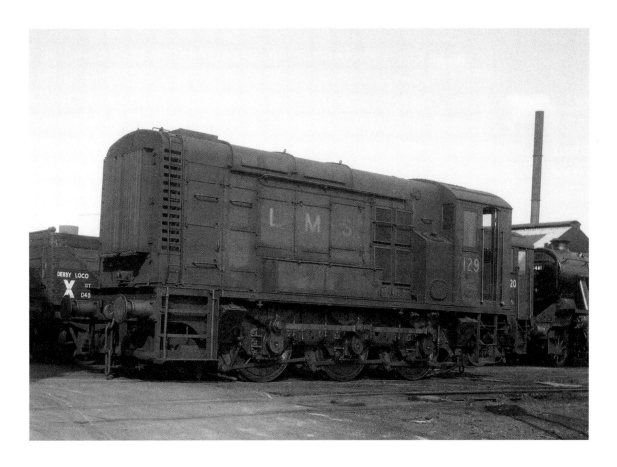

Thursday, 30 July 1953. Still bearing its former owner's identity and number, 7129 entered service during 1947 from Derby Works and is seen here at that works, awaiting an overhaul. It would emerge from the works later that year as No. 12042, but would give only twenty years' service before being withdrawn in 1969. (Ron Buckley)

This spread of photographs shows three examples of the BR Class D3/2 diesel electric 0-6-0 shunters as they appeared ex-works. This class would become Class 08 in the TOPS scheme.

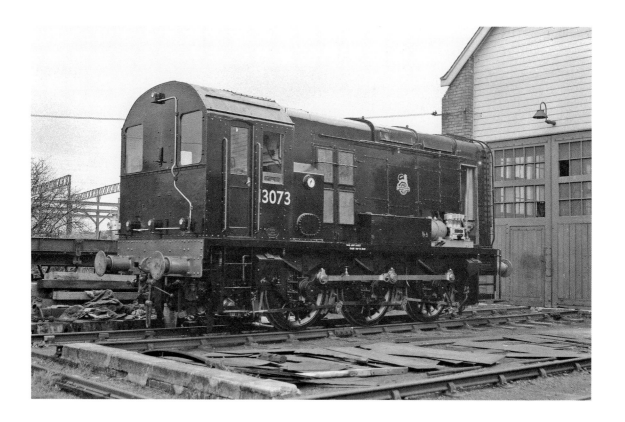

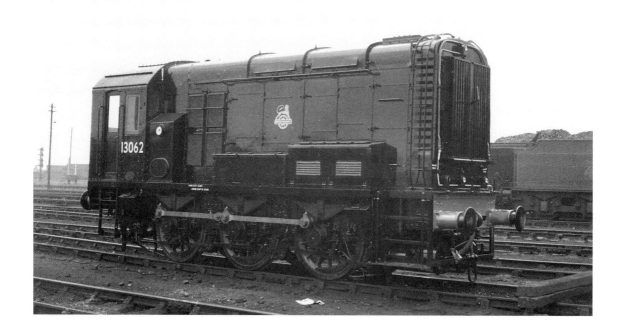

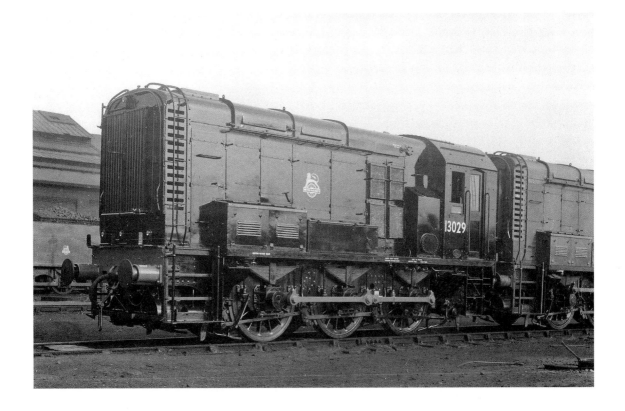

Opposite top: **Tuesday, 11 August 1953**. No. 13073 is seen standing outside Darlington Works prior to entering service later that year; it would later be renumbered D3073 and then 08 059 in the TOPS scheme. Spending most of its life working in the Gateshead area, it would be withdrawn during 1980. (Robert Butterfield)

Opposite bottom: **Saturday, 29 August 1953**. No. 13062 is seen in Darlington shed yard, soon to be allocated to Mexborough depot. It would be numbered D3062, before being classed as 08 049 in the TOPS scheme, giving twenty years of service before being withdrawn during 1981. (Andrew Forsyth)

Above: **Friday, 23 October 1953**. Waiting for delivery to Tyseley depot is 350hp 0-6-0 shunter No. 13029, having exited Derby Works earlier in the month. After being renumbered D3029, it would become No. 08 021 under the TOPS scheme until its withdrawal in 1986. After being purchased in 1987 by the Birmingham Railway Museum, it is now based and operational at Tyseley Locomotive Works. (Ron Buckley)

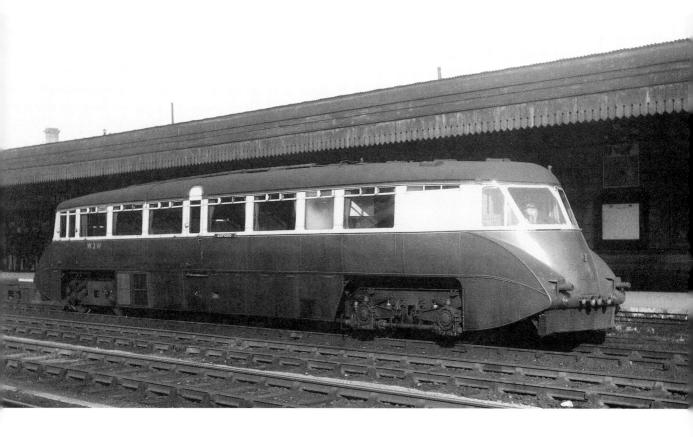

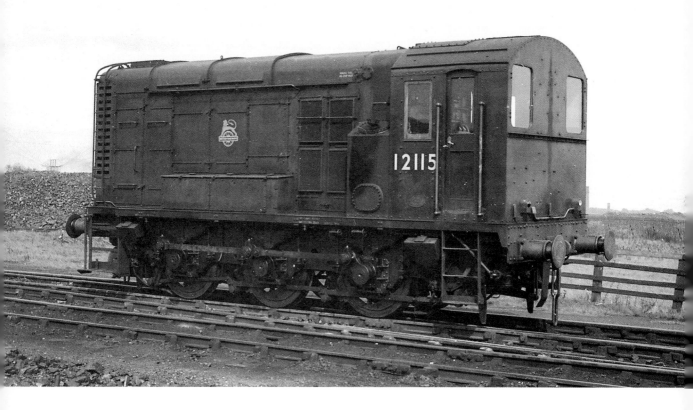

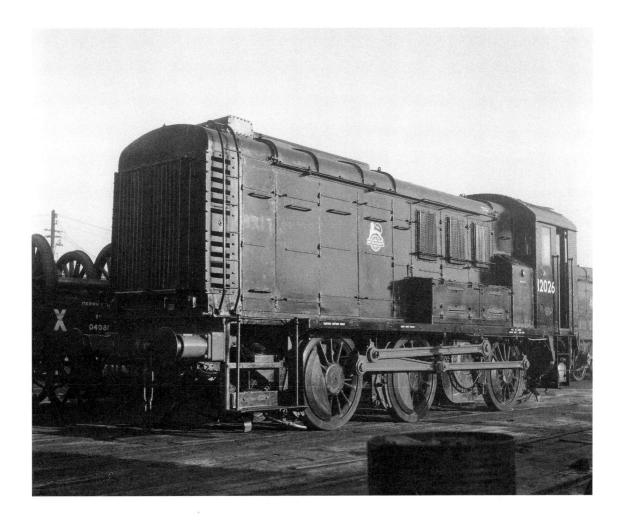

Opposite top: **Saturday, 27 February 1954**. Waiting to depart from Oxford station with the 2.40 p.m. working to Princes Risborough is ex-GWR Railcar No. W3W. Constructed by AEC Ltd during 1934, it has the striking art deco lines of the period and would see twenty-one years of service before being withdrawn in 1955. The passenger service itself, which traversed the Oxfordshire and Buckinghamshire countryside via Cowley and Thame, would be withdrawn in January 1963. (Ron Buckley)

Opposite bottom: **Friday, 3 September 1954**. Standing in Darlington depot yard, No. 12115 was constructed at the works there during 1952, as part of a post-nationalisation order for these former LMS-designed shunters. Allocated in the Hull area until 1956, it would be based at Stratford for the remainder of its working life, with withdrawal coming in 1970. (Andrew Forsyth)

Above: **Friday, 10 December 1954**. In ex-works condition, after having completed an overhaul at Derby Works, ex-LMS 0-6-0 diesel shunter No. 12026 had been constructed at Derby during 1942, utilising the jackshaft method of drive. Originally numbered 7113 by that company, it would be withdrawn after twenty-five years' service in 1967. (Ron Buckley)

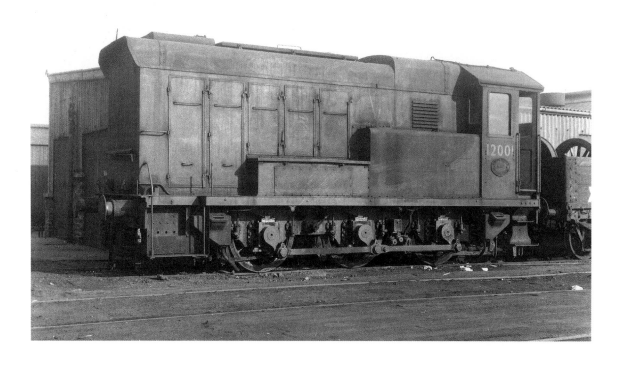

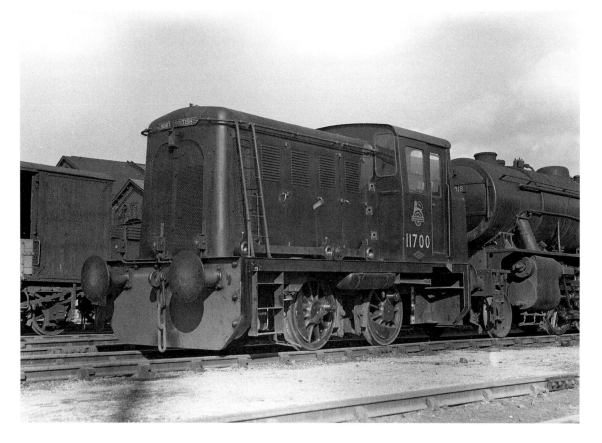

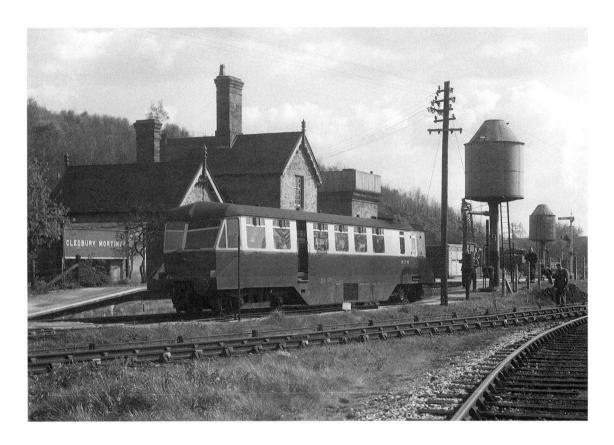

Opposite top: **Monday, 21 February 1955**. Seen here in Derby Works yard is one of the earliest of the ex-LMS diesel shunters. Constructed by English Electric Hawthorn Leslie Works during 1935, it was originally numbered 7076 by the LMS before becoming 12001 with BR. It would be withdrawn in 1962. (Ron Buckley)

Opposite bottom: **Sunday, 3 April 1955**. Sitting in Darlington Works yard minus its coupling rods is NBL-constructed 0-4-0 diesel hydraulic shunter No. 11700. Entering service during 1953 as part of a class of eight examples supplied by the NBL, it would later be numbered D2700 before being withdrawn in 1963. (Robert Butterfield)

Above: **Saturday, 21 May 1955**. This day saw the running of the Stephenson Locomotive Society West Midland Railtour, which visited branches and lines in the Birmingham and Wolverhampton areas. Photographed at Cleobury Mortimer station is ex-GWR Railcar No. W19W; constructed at its Swindon Works during 1940, it would be withdrawn in 1960. Cleobury Mortimer itself would lose its passenger service during August 1962. (Ron Buckley)

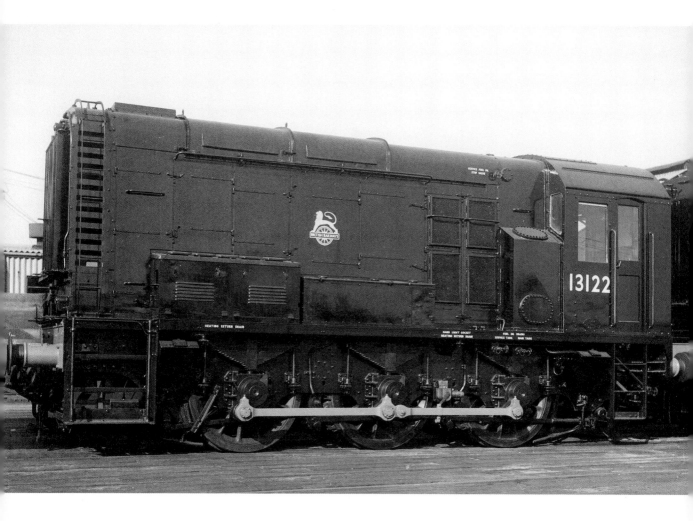

Friday, 5 August 1955. Having just emerged from Derby Works and waiting to be delivered to its first allocation (which would be Toton depot), 350hp shunter No. 13122 is bearing the early 'Lion and Wheel' BR identity. It would later be numbered D3122, but would only give eleven years of service before being withdrawn in 1966. (Ron Buckley)

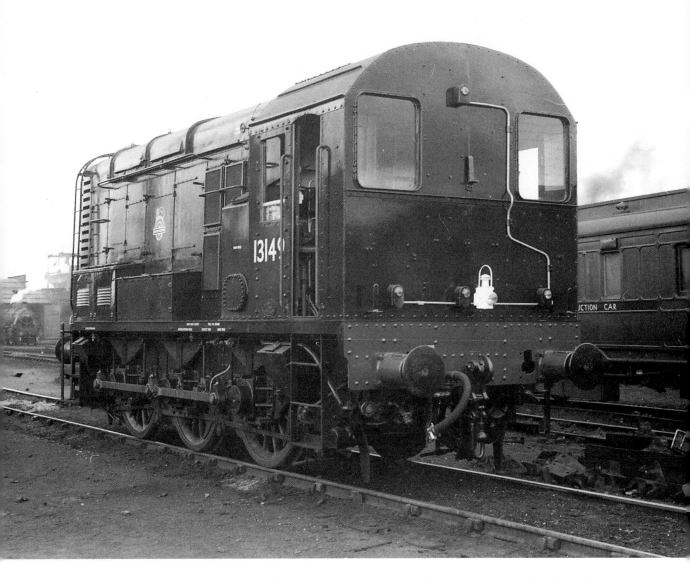

Saturday, 6 August 1955. In Darlington depot yard, 0-6-0 shunter No. 13149 is also in ex-works condition, awaiting delivery to its first shed. It would be numbered D3149 and be withdrawn during 1970. (Andrew Forsyth)

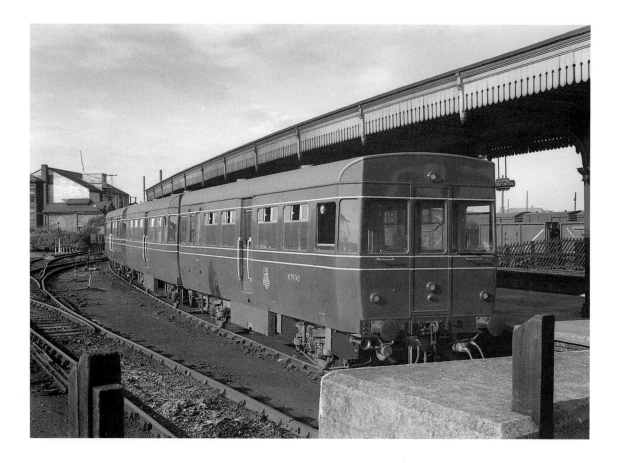

September 1955. During April and May 1952, the demonstration train sponsored by Associated Commercial Vehicles (ACV) tested at various branch lines in Great Britain. Constructed by British United Traction (BUT), a subsidiary of both Leyland and AEC, the bodywork was constructed by Park Royal Coachworks and fitted with AEC engines. By the time of this photograph they were primarily restricted to working the Watford Junction to St Albans Abbey branch. Seen here at Watford Junction, waiting to depart to St Albans, is No. M79743, part of the three-car set. (Andrew Forsyth)

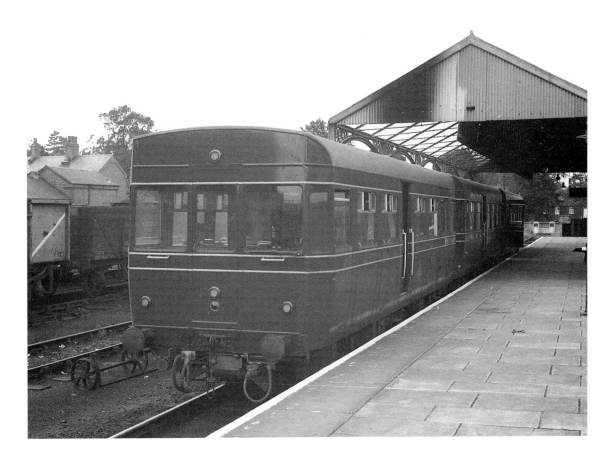

September 1955. The same three-car set as seen opposite is here at St Albans Abbey station, waiting to depart with the return working to Watford Junction. A total of eleven cars were constructed, but by the early 1960s all the units had been withdrawn from service to storage at Derby; all would be scrapped by 1963. (Andrew Forsyth)

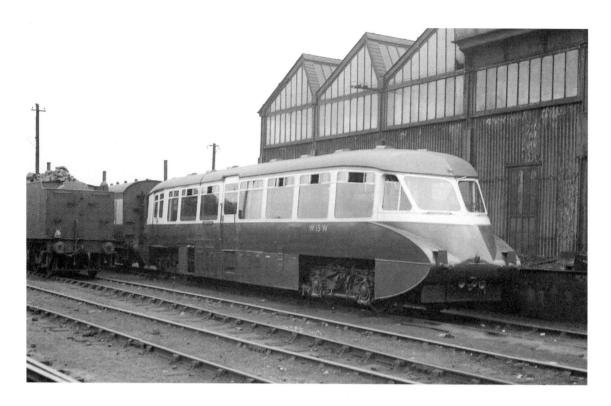

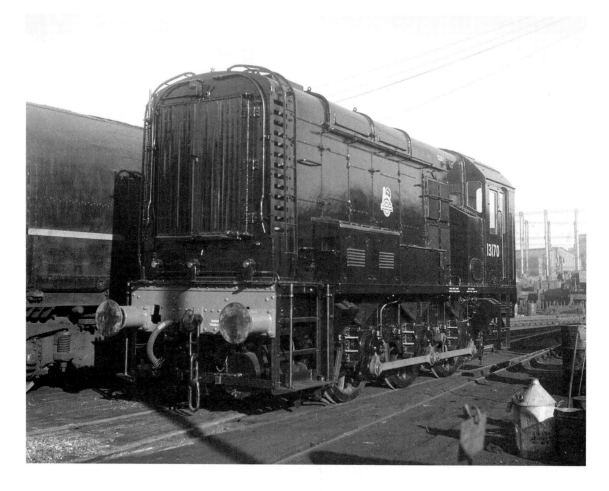

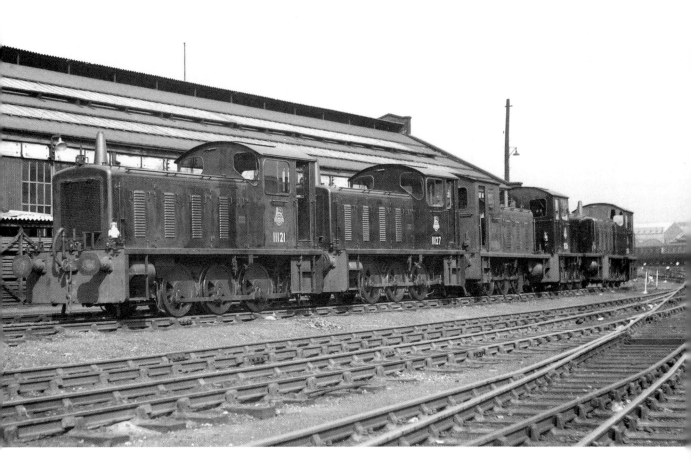

Opposite top: **4 September 1955**. Parked in the yard at Oxford depot is ex-GWR Railcar No. W15W; constructed by the GRC&W during 1936, it would be withdrawn from service in 1959. (Robert Butterfield)

Opposite bottom: **12 September 1955**. In ex-works condition and waiting delivery to Carlisle Upperby depot, its first allocation, 350hp 0-6-0 shunter No. 13170 would later be numbered D3170. Renumbered 08 105 in the TOPS scheme, it would give twenty-eight years of service before being withdrawn during 1983. (Ron Buckley)

Above: **Sunday, 25 September 1955**. A quiet Sunday in Stratford depot yard sees a line of Drewry Car Co.-supplied 0-6-0 diesel mechanical shunters Nos 11121, 11127, 11110 and 11126, which would be renumbered D2215, D2221, D2209 and D2220. Entering service between 1953 and 1955, all would be withdrawn during 1968 and 1969, with No. D2209 being sold to the National Coal Board to work at Kiverton Colliery in Yorkshire before being scrapped in 1985. (Robert Butterfield)

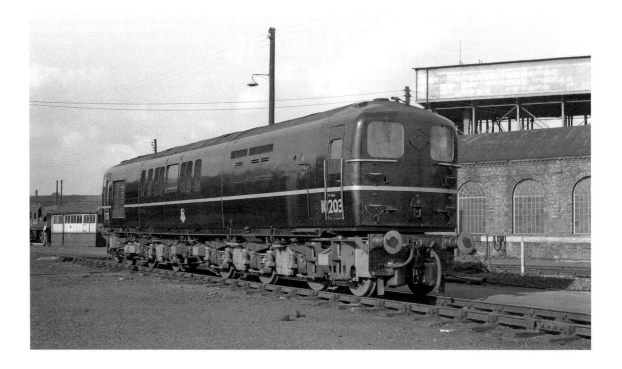

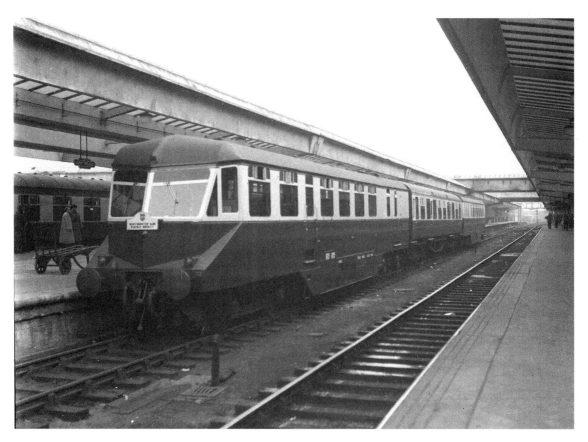

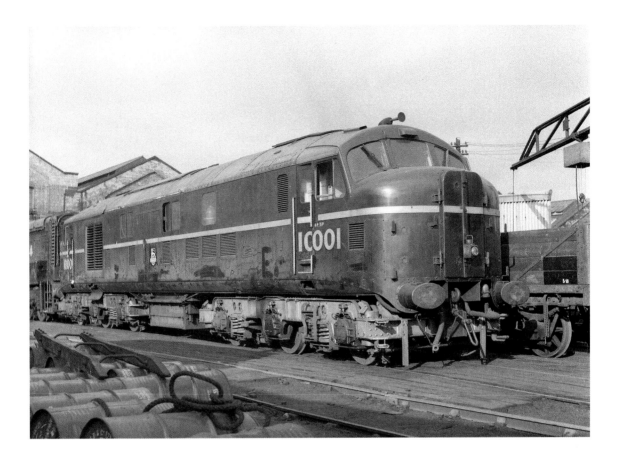

Opposite top: **Sunday, 25 September 1955**. Constructed at the ex-SR Brighton Works, diesel electric No. 10203 is seen here at Willesden depot. Entering service during 1954, it would spend some time being evaluated on the LMR based at Camden depot and later at Willesden depot before withdrawal came in 1963.

Its two sister locomotives, Nos 10201 and 10202, were constructed at Ashford Works during 1950 and 1951, and they too would be withdrawn in 1963. Classified D16/2 by BR, they would carry the Steam Power Classification 7P6FA on their cabsides. (Robert Butterfield)

Opposite bottom: **Sunday, 2 October 1955**. Seen at Derby Midland station is the Westminster Bank Railway Society special, comprising ex-GWER railcars Nos W33W and W38W, with TK coach No. W1096W running between them. Railcar No. W33W had originally been constructed at Swindon Works as a conventional double-ended railcar during 1941 and was converted to a single driving end railcar with a corridor connection in 1951. No. W38W had also been constructed at Swindon Works, but in 1942 and with a single driving end and corridor connection. Both cars would be withdrawn during 1962. (Ron Buckley)

Above: **Saturday, 5 November 1955**. Diesel electric locomotive No. 10001 is seen here in Derby Works yard sporting the original black livery that it entered service with. It would emerge from the works with a new green livery. (Ron Buckley)

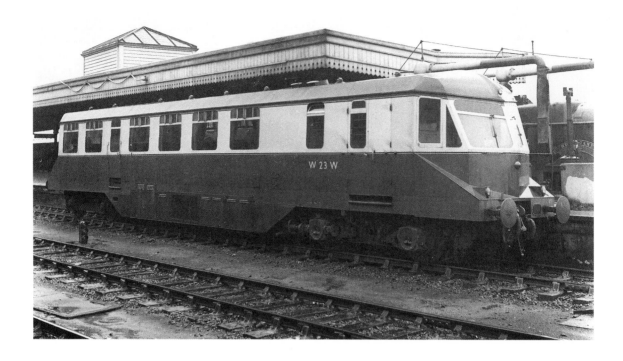

Above: **Saturday, 14 April 1956**. At Bristol Temple Meads station, ex-GWR Railcar No. W23W awaits its next duty. Constructed at Swindon Works during 1940, it would be withdrawn in 1962. (Ron Buckley)

Opposite: **Friday, 18 May 1956**. Seen here in ex-works condition in Derby Works yard, 350hp 0-6-0 diesel electric shunter No. 13252 would initially be allocated to Grimethorpe depot in Sheffield. It would be renumbered D3252 and finally 08 184 in the TOPS scheme, before being withdrawn during 1981. (Ron Buckley)

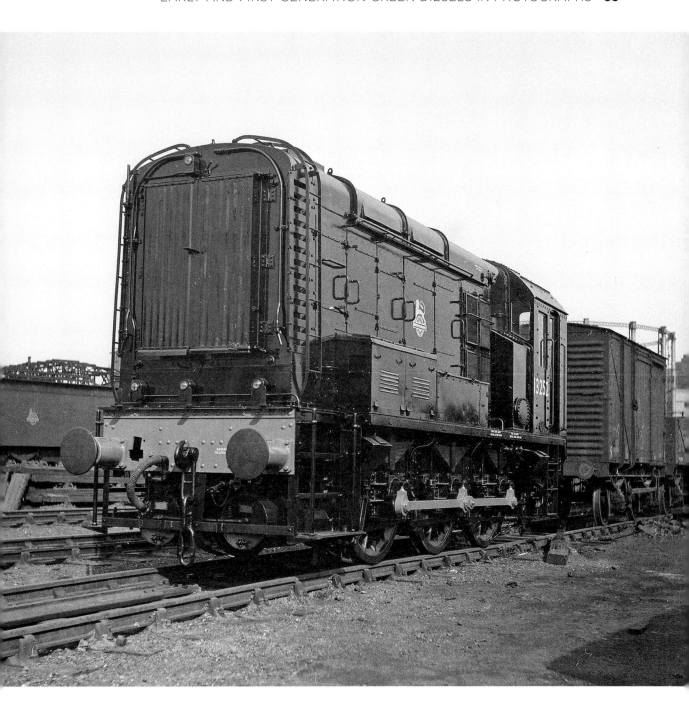

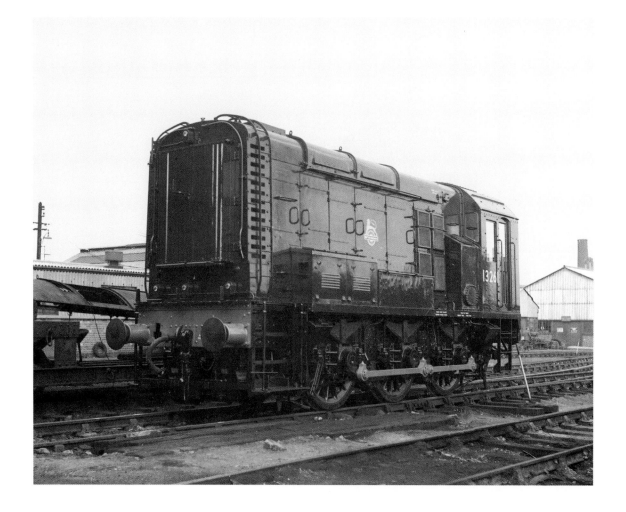

Above: **Friday, 6 July 1956**. Having entered service earlier in the week, 350hp 0-6-0 diesel electric shunter No. 13261 is seen in Derby shed yard painted in the new green livery. Later becoming No. D3261, it would be withdrawn from service during 1972 and pass into the preservation scene, where it can currently be seen in service at the Swindon and Cricklade Railway. (Ron Buckley)

Opposite top: **Friday, 31 August 1956**. In grimy condition standing in the yard at Derby Works and bearing the early BR identity, LMS-designed 350hp 0-6-0 shunter No. 12046 entered service during 1948 from the same works. It would give twenty years' service before being withdrawn in 1969. (Ron Buckley)

Opposite bottom: **Saturday, 29 December 1956**. Also seen in Derby Works yard is ex-Darlington Works 1954-constructed 350hp 0-6-0 shunter No. 13127. It would become No. D3127 and finally No. 08 092 in the TOPS scheme and give almost twenty-five years of service before being withdrawn during 1978. (Ron Buckley)

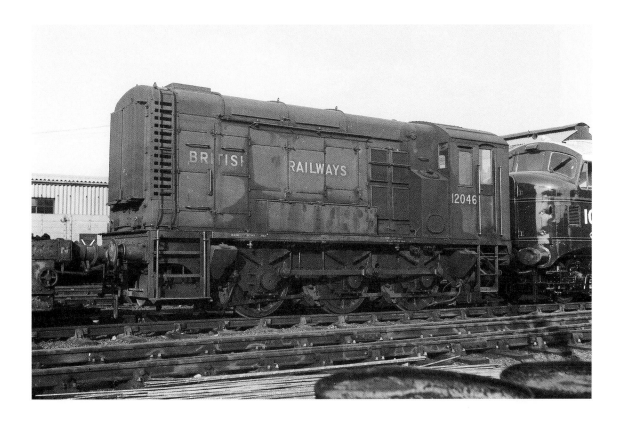

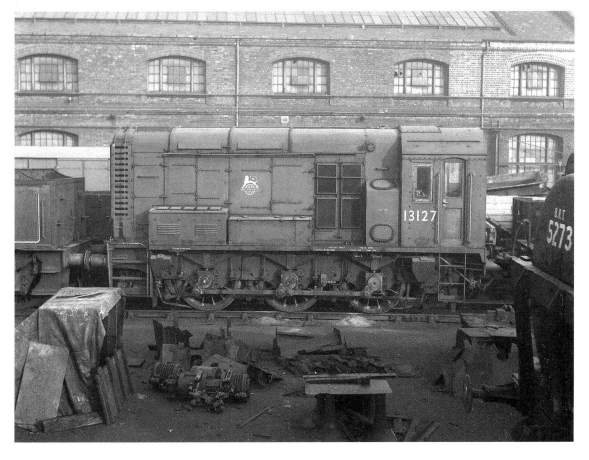

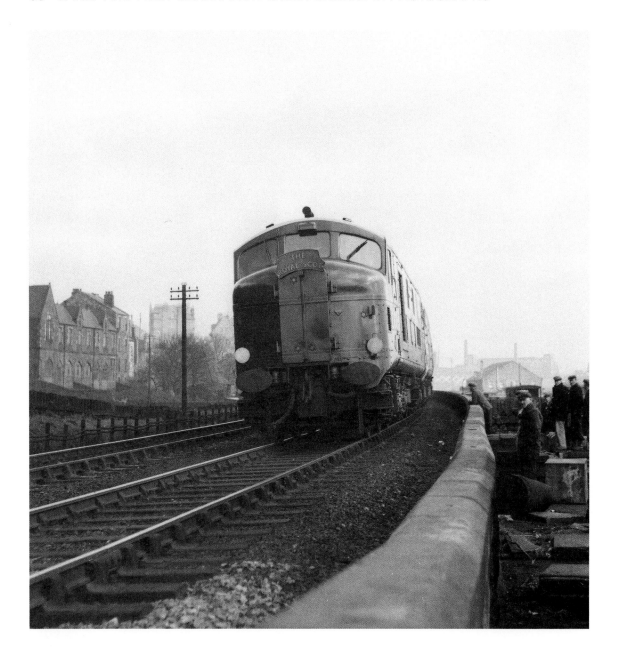

Monday, 8 April 1957. Leaning into the curve whilst accelerating away from Carlisle station is No. 10000, at the head of the 'Royal Scot' and leading its sister No. 10001. Having spent much of 1953 and 1954 working and being evaluated on the Southern Region, they both returned to the London Midland Region in 1956. Classified D16/1 by BR, the pair would bear the Steam Power Classification 6P5F on their cabsides. (Robert Butterfield)

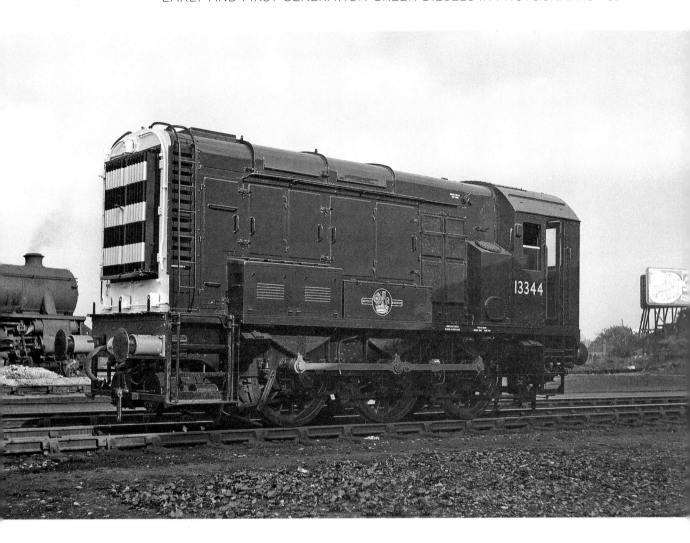

Friday, 26 April 1957. Seen standing in Derby shed yard is 350hp 0-6-0 diesel electric shunter No. 13344, sporting an experimentally painted front to the locomotive. Entering service during the same week, it would be allocated to Dunfermline depot and later be numbered D3344 before becoming 08 274 in the TOPS scheme. It would end its days based at Gateshead, being withdrawn from there in 1984. (Ron Buckley)

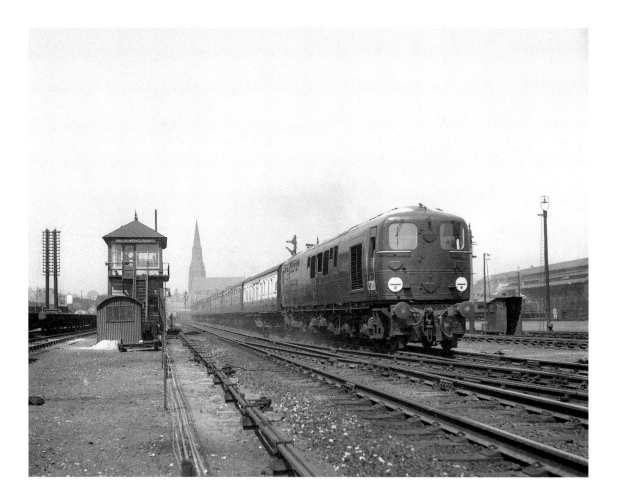

Above: **Wednesday, 22 May 1957**. With the impressive spire of St Andrew's Church in the background, diesel electric locomotive No. 10201 is seen passing the Way & Works Sidings 'box at the head of the 12.05 p.m. Derby to London St Pancras working. Constructed at Ashford Works during 1950, it would spend much of 1951 on the London Midland Region undergoing trials, before being returned to the Southern Region in 1952. The later 1950s saw it move back to the London Midland Region, where it would be withdrawn from service in 1963. (Ron Buckley)

Opposite top: Friday, 5 July 1957. In ex-works condition at Derby Works, 350hp 0-6-0 shunter No. D3360 is waiting delivery to a South Wales depot allocation. Becoming 08 290 under the TOPS scheme, it would be withdrawn in 1982, after twenty-five years of service. (Ron Buckley)

Opposite bottom: **Saturday, 7 September 1957**. Another 350hp 0-6-0 shunter also in Derby Works yard is No. D3379, which is waiting delivery to Royston depot. After being renumbered 08 309 in the TOPS scheme, it would be withdrawn during 1992, having seen thirty years of service. (Ron Buckley)

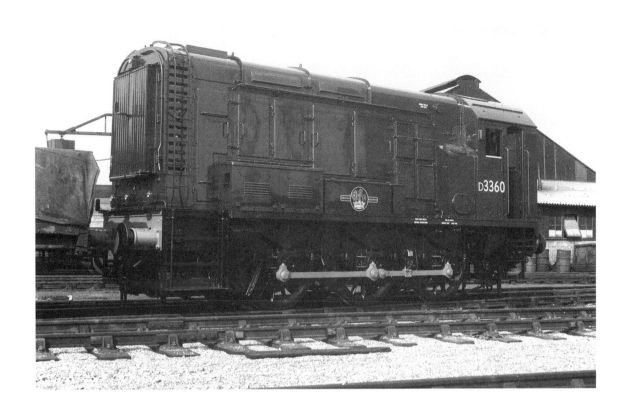

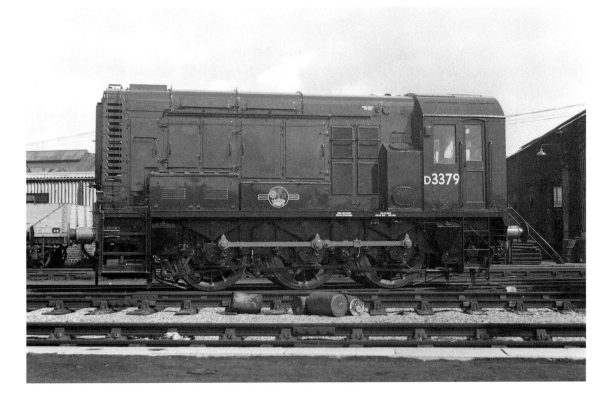

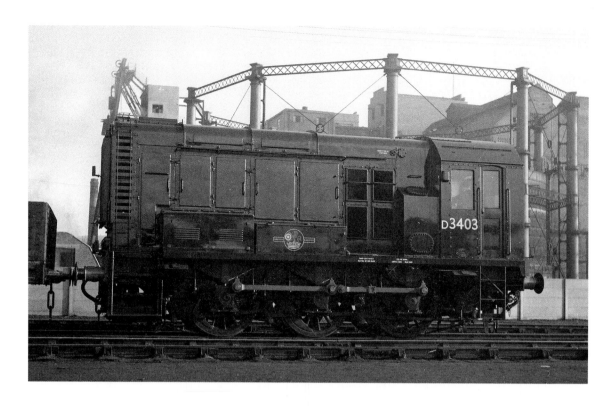

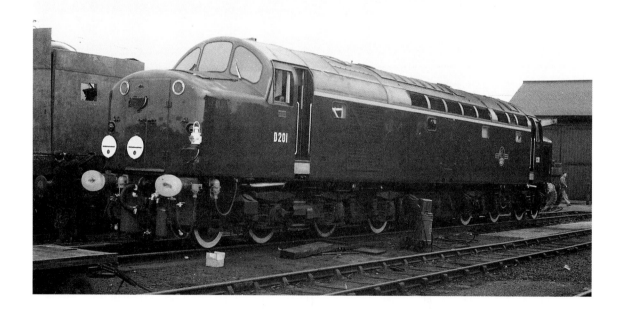

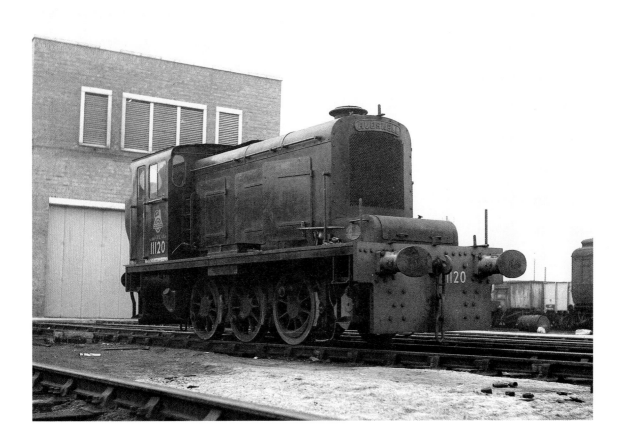

Opposite top: **Saturday, 14 December 1957**. In sparkling condition, 350hp 0-6-0 diesel electric shunter No. D3403 is seen in Derby shed yard, having just entered service. It would become 08 833 under the TOPS scheme, before being withdrawn during 1982. (Ron Buckley)

Opposite bottom: **Monday, 14 April 1958**. One of the successes of the Pilot Scheme was undoubtedly the English Electric-constructed Type 4s (Class 40), which started to enter service during March 1958. With 200 examples constructed over a period of four years, they would be allocated widely throughout the Eastern, North Eastern, Scottish and London Midland Regions of BR. Seen here in Doncaster Works yard, ex-works and awaiting delivery to Stratford depot, is No. D201. It would be renumbered 40 001 in the TOPS scheme and be withdrawn during 1984. (Andrew Forsyth)

Above: **Saturday, 19 April 1958**. Hudswell Clarke-constructed 0-6-0 diesel electric shunter No. 11120 is seen here in Derby Works yard, minus its coupling rods. Later numbered D2504, it would spend its working life allocated to Birkenhead depots, but only give eleven years of service before being withdrawn in 1967. (Ron Buckley)

Above: **Saturday, 26 April 1958**. Waiting in Tenbury Wells station whilst a porter unloads parcels, ex-GWR railcar No. W20W is working the 11.10 a.m. Bewdley to Wofferton service. Constructed at Swindon Works during 1940, it would be withdrawn during 1962 but find its way into the preservation scene. At the time of writing, it is undergoing a major rebuild at the Kent and East Sussex Railway. The station at Tenbury Wells closed after withdrawal of the service from Bewdley in August 1962. (Ron Buckley)

Opposite: **Saturday, 26 April 1958**. Standing in platform 1 at Bewdley station, ex-GWR railcar No. W32W waits to depart with a service to Wofferton. Constructed at Swindon Works during 1941, it would also be withdrawn in 1962; fortunately, Bewdley station itself is still in operation as part of the Severn Valley Railway. (Ron Buckley)

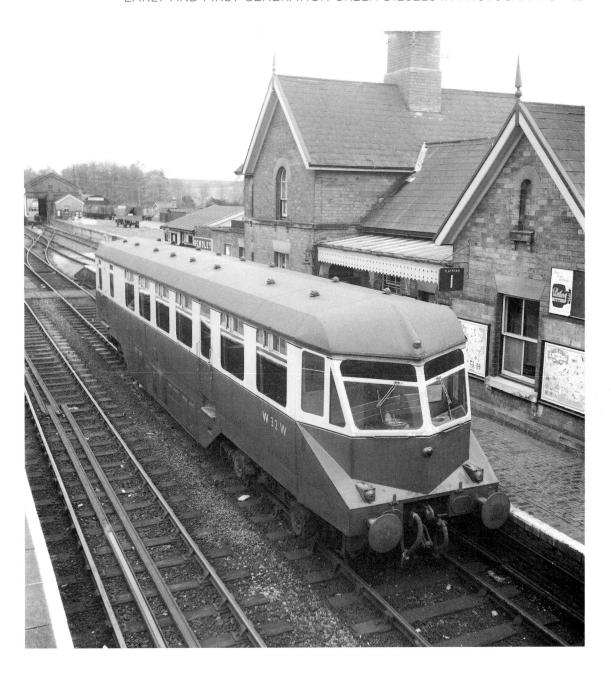

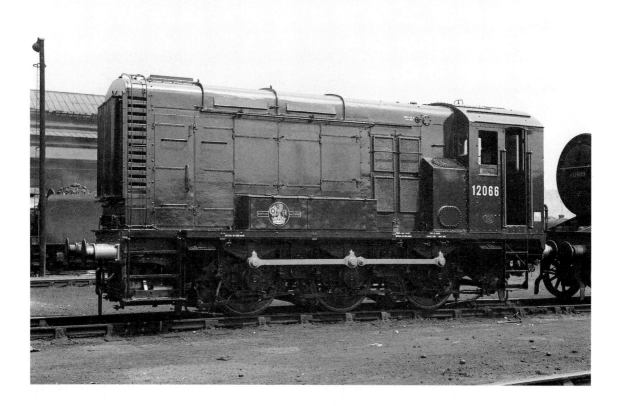

Above: **Friday, 11 July 1958**. Standing in Derby Works yard, newly painted in green livery, is 350hp 0-6-0 shunter No. 12066 bearing the later BR emblem. Constructed at the same works during 1949, it would be withdrawn in 1969. (Ron Buckley)

Opposite top: **Saturday, 26 July 1958**. With two young enthusiasts showing interest in the locomotive whilst it awaits its next duty near Peterborough East station, this is another example of the Pilot Scheme successes. English Electric Type 1 (Class 20) No. D8002 is one year into its service life, having been constructed at the Vulcan Foundry during July 1957. It would be renumbered 20 002 under the TOPS scheme before being withdrawn in 1988. (Ron Buckley)

Opposite bottom: **Saturday, 2 August 1958**. Seen approaching Retford station at the head of the 1.25 p.m. Hull to London Kings Cross express is English Electric Type 4 (Class 40) No. D206. Barely a month old, it would spend much of its working life based at Eastern Region depots before working out of Liverpool and Manchester depots. It would be numbered 40 006 in the TOPS scheme and be withdrawn during 1983. (Ron Buckley)

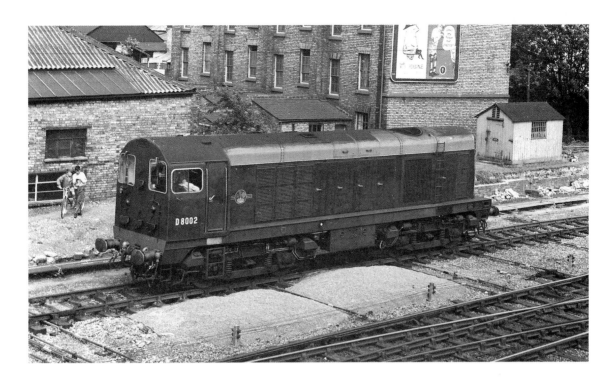

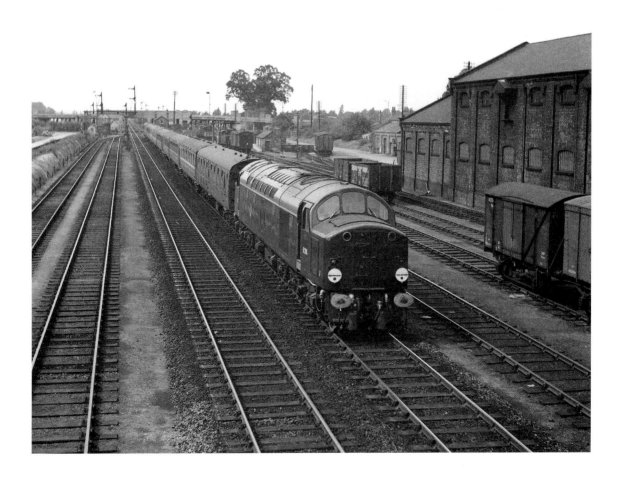

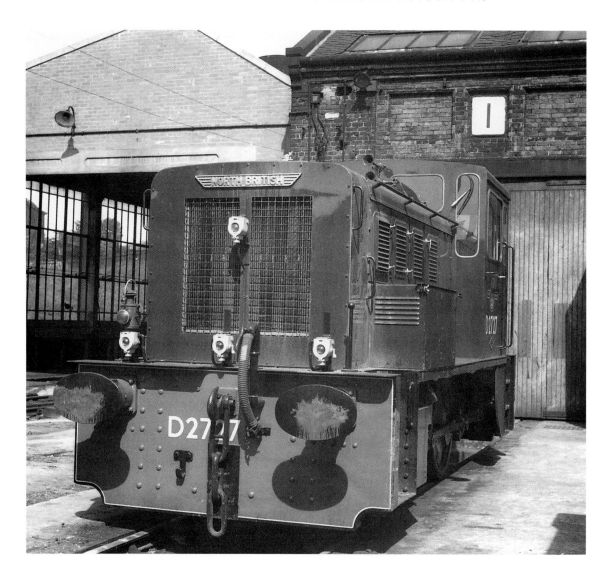

Sunday, 24 August 1958. At Eastfield depot in Glasgow, 0-4-0 diesel hydraulic shunter No. D2727 has just been delivered from the NBL and is waiting to move to St Margaret's depot in Edinburgh, where it will be based for its entire working life. A total of seventy-three examples were produced between 1957 and 1961, all being allocated to Scottish sheds. D2727 itself would be withdrawn during 1967. (Andrew Forsyth)

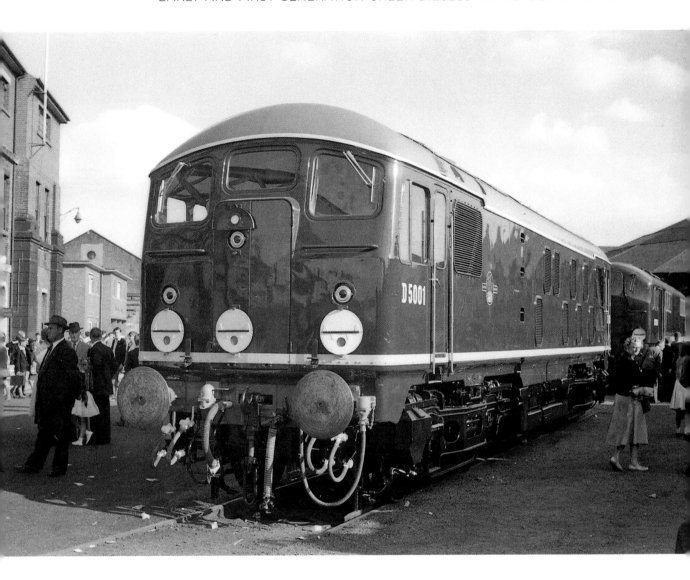

Saturday, 30 August 1958. It's Derby Works' open day and BR/Sulzer Type 2 (Class 24) No. D5001 is on display. Constructed at the same works, it is yet to enter service, but will be allocated to Crewe South depot. Renumbered 24 001 in the TOPS scheme, it would be withdrawn initially in 1969, only to be reinstated during the same year and finally withdrawn from service in 1975. (Andrew Forsyth)

Above: **Saturday, 30 August 1958.** At the same Derby Works open day, Metropolitan/ Vickers-constructed Type 2 (Class 28) No. D5700 will work out of Derby depot for a couple of years before being allocated to Barrow-in-Furness along with the rest of the class of twenty examples. Fitted with the Crossley two-stroke diesel engine, which would become troublesome, the entire class had been withdrawn from service by 1968. One example survived into the preservation scene, No. D5705, but it is yet to return to service. (Andrew Forsyth)

Opposite top: **Thursday, 16 October 1958**. Another example of the Drewry Car Co.- supplied 0-6-0 diesel mechanical shunter is seen here at Derby Works, minus its coupling rods. Constructed during 1955, No. 11124 would become No. D2218 and be allocated to depots as widely spread as Norwich Thorpe, Immingham, Crewe South, Chester and Birkenhead, before being withdrawn during 1968. (Ron Buckley)

Opposite bottom: **Monday, 12 January 1959**. Having exited Derby Works this week and waiting delivery to its first allocation, BR/Sulzer Type 2 (Class 24) No. D5005 is in shining ex-works condition. It would only see a short ten years of service before being withdrawn during 1969. (Ron Buckley)

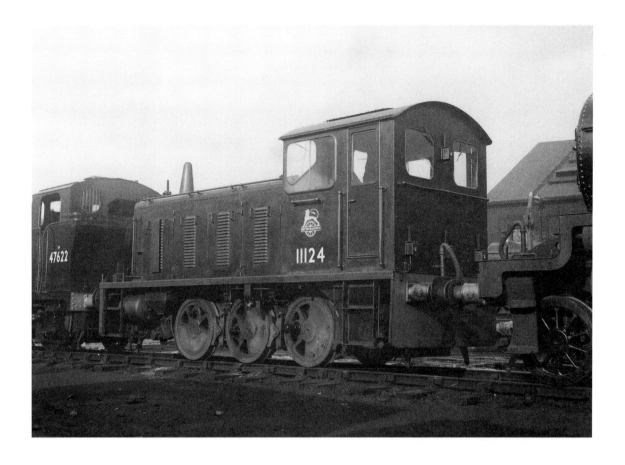

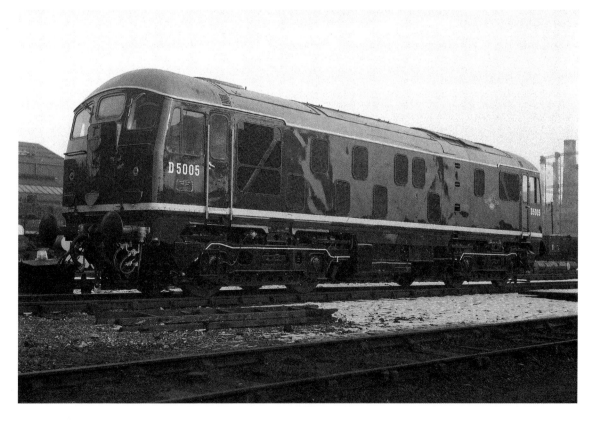

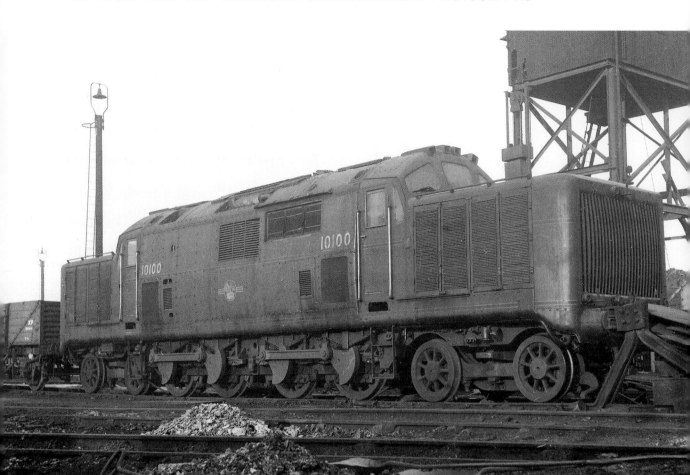

This spread shows the wide difference in style of design between two of the most interesting prototype diesel locomotives that came from engineers' drawing boards during the early 1950s. The 'Fell' locomotive (above) adheres rigidly to the mechanical method of traction compared to the 'Deltic' (right), which choses to utilise two high-speed diesel engines coupled with electric traction. The clear winner was the Deltic: a subsequent order for further units meant that the class saw regular 100mph running on passenger expresses between London and Edinburgh.

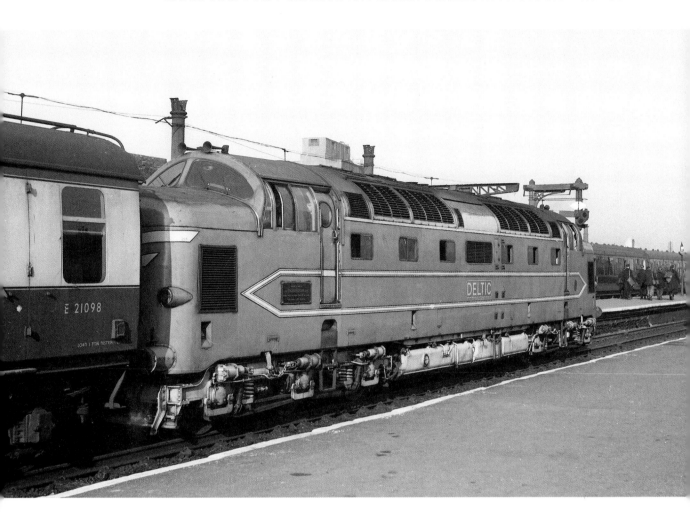

Opposite: **Monday, 12 January 1959**. Shunted into a dead-end siding at Derby Works is the Fell locomotive No. 10100, having been withdrawn from service during the later part of 1958 after a serious fire on board. Originally constructed with a 4-8-4 wheel arrangement, at some time it had been converted to a 4-4-4-4 configuration, as seen in this photograph. Scrapping would follow during 1960. (Ron Buckley)

Above: **Saturday, 28 February 1959**. Entering service in December 1955, the DP1 (or Deltic) locomotive had been constructed by the English Electric Co., utilising two Napier and Sons Deltic two-stroke diesel engines. It proved itself in traffic with the Eastern, North Eastern and Scottish Regions, which led to a production order for twenty-two locomotives from English Electric: the Type 5 (Class 55) series, numbered D9000 to D9021. The Deltic, seen here at Peterborough heading north, would be withdrawn from service during 1961 and donated to the Science Museum in London. (Ron Buckley)

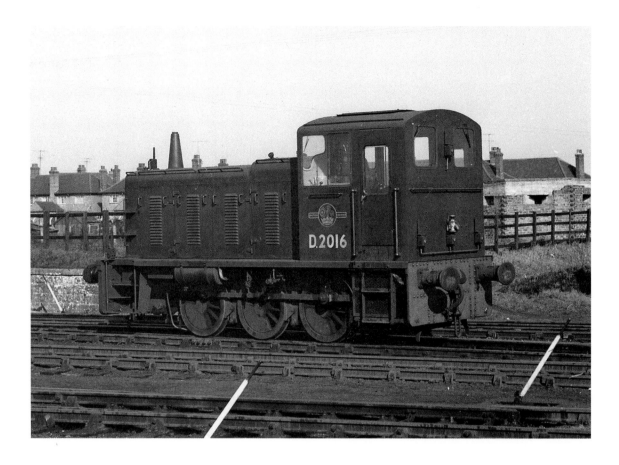

Saturday, 28 February 1959. Standing in South Lynn yard is Swindon Works-constructed 0-6-0 diesel mechanic shunter (Class 03) No. D2016. Entering service barely a year earlier, it would spend its entire working life based at East Anglian depots, being renumbered 03 016 in the TOPS scheme and withdrawn during 1978. (Ron Buckley)

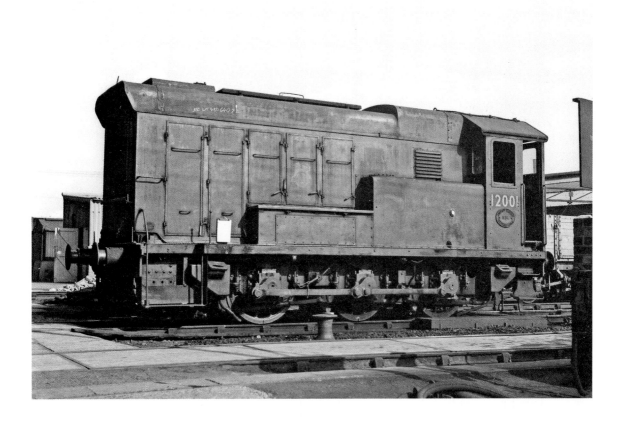

Friday, 13 March 1959. Standing in Derby Works yard is the 1935-constructed ex-LMS 0-6-0 shunter No. 12001. See the enlargement of the builder's works plate: English Electric Hawthorn Leslie 1935. (Ron Buckley)

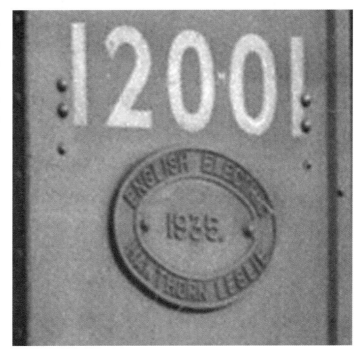

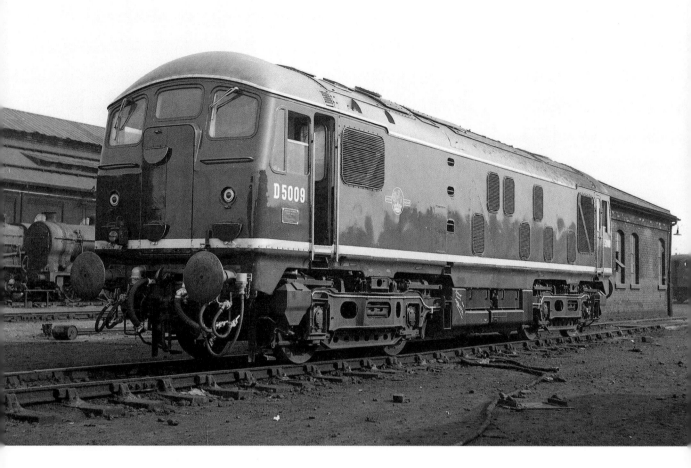

Friday, 13 March 1959. Waiting delivery to its first allocation, BR/Sulzer Type 2 (Class 24) No. D5009 is standing in Derby Works yard, having exited the works a few days earlier. Becoming No. 24 009 in the TOPS scheme, it would spend three years based at Hither Green depot before moving north to Crewe. It spent its last years at Eastfield in Glasgow and Haymarket in Edinburgh, until it was withdrawn from service during 1976. (Ron Buckley)

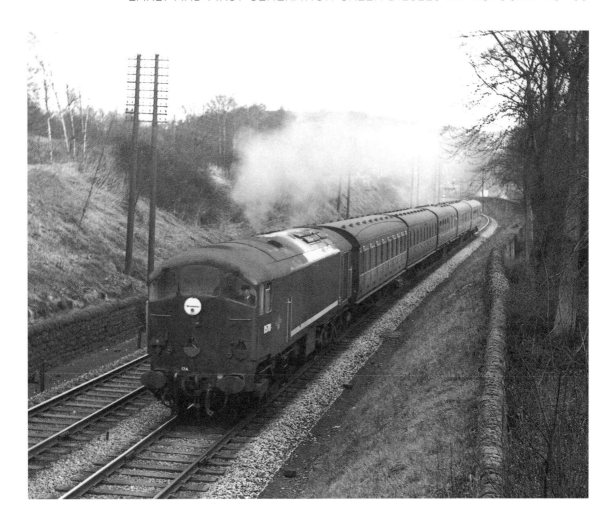

Saturday, 28 March 1959. With a 17A Derby shed code painted on the front bodywork and leaving in its wake the usual distinctive two-stroke diesel smoke screen, Metropolitan/Vickers Type 2 (Class 28) No. D5701 is seen here near Ambergate, at the head of the 4 p.m. Derby to Manchester Central working. (Ron Buckley)

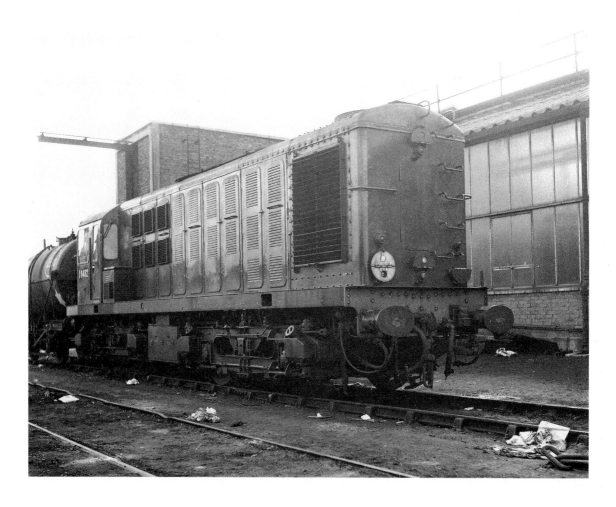

Wednesday, 8 April 1959. Delivered from the NBL in Glasgow during July 1958, Type 1 No. D8402 would have a very brief working life of only ten years, being withdrawn in July 1968. Based at Stratford for its entire working life, it is seen here in the yard. (Ron Buckley)

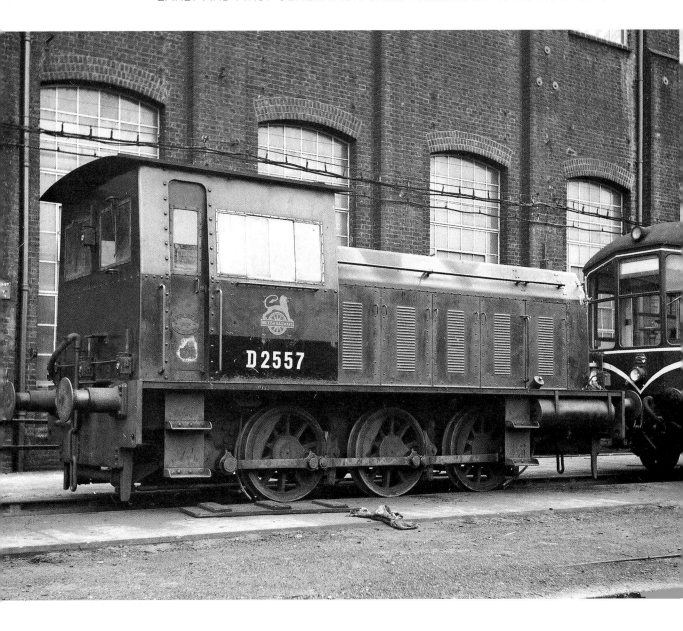

Saturday, 18 April 1959. At Stratford depot yard, Hunslet-constructed 0-6-0 diesel mechanical shunter No. D2557 has just been renumbered. Formerly No. 11143, it had entered service during 1956 and would be withdrawn in 1967. (Ron Buckley)

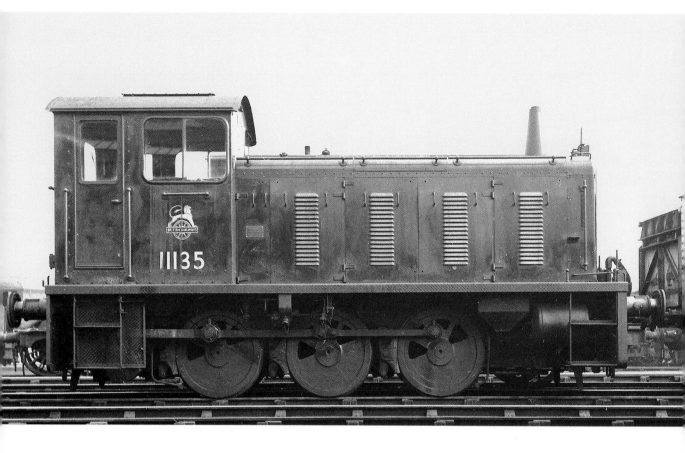

Saturday, 18 April 1959. Drewry Car Co.-supplied 0-6-0 diesel mechanical shunter No. 11135 of 1955 would later be renumbered D2229 and spend much of its working life based at East Anglian depots. Seen here in Stratford depot yard, it would spend its last year at Gateshead and be withdrawn in 1969, after which it was sold to the NCB. It would work at several collieries before finally finding its way into the preservation scene during 1990; it is currently owned by the Heritage Shunters Trust and can be found at Peak Rail. (Ron Buckley)

Monday, 11 May 1959. In sparkling ex-works condition, BR/Sulzer Type 4 (Class 44) No. D1 *Scafell Pike* is standing in the yard at Derby Works. Entering revenue-earning service later that year, it would be renumbered 44 001 in the TOPS scheme but be withdrawn during 1976. (Ron Buckley)

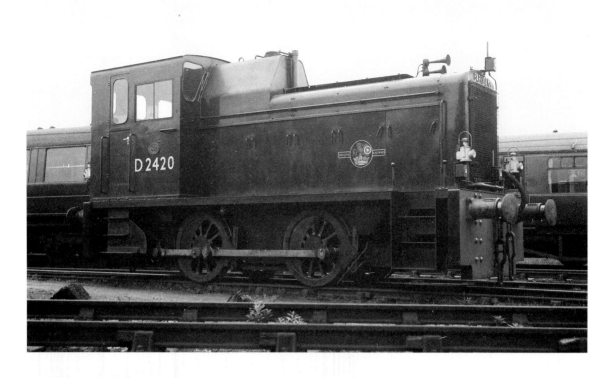

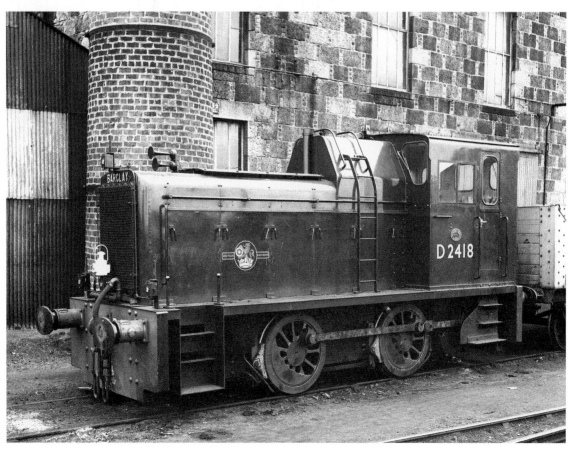

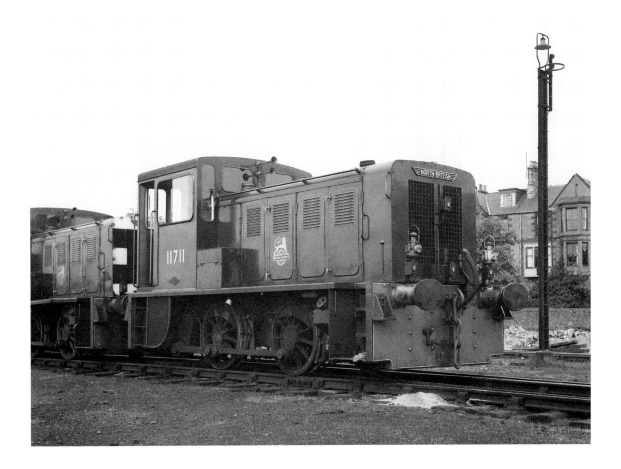

Saturday, 16 May 1959. A visit to the North East of Scotland brought the opportunity to photograph two examples of the Andrew Barclay & Son-constructed 0-4-0 diesel mechanical shunters that became the Class 06.

Opposite top: No. D2420 is seen at Kittybrewster yard, having entered service only three months earlier. It would be renumbered 06 003 in the TOPS scheme before being withdrawn during 1981 and transferred to departmental stock. It found work at Reading signal works, where it would be numbered 97804 until it was finally withdrawn from service during 1984. Bought privately, it would see some work in the commercial hire market, and during 2012 would join the Heritage Shunters Trust fleet based at Peak Rail, Rowsley. (Ron Buckley)

Opposite bottom: Standing in Inverurie Works yard is No. D2418. Entering service four months earlier, it would be based at Kittybrewster in Aberdeen for its entire working life until it was withdrawn from service in 1968. (Ron Buckley)

Above: **Sunday, 17 May 1959**. Bearing the distinctive diamond shape builder's plate, NBL-constructed 0-4-0 diesel hydraulic shunter No. 11711 is parked in the yard at Dundee West depot. Entering service during 1957, it would be renumbered D2711 but be withdrawn from service only ten years later, in 1967. (Ron Buckley)

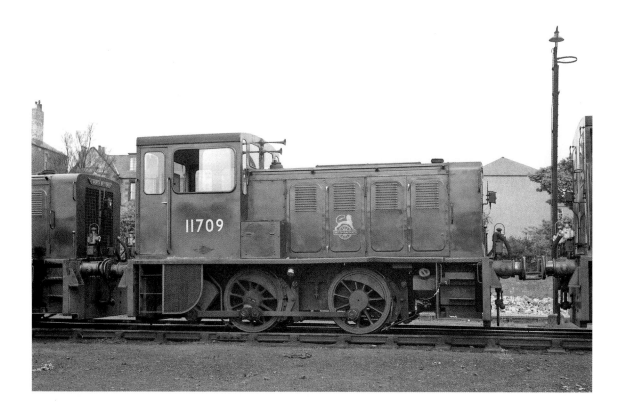

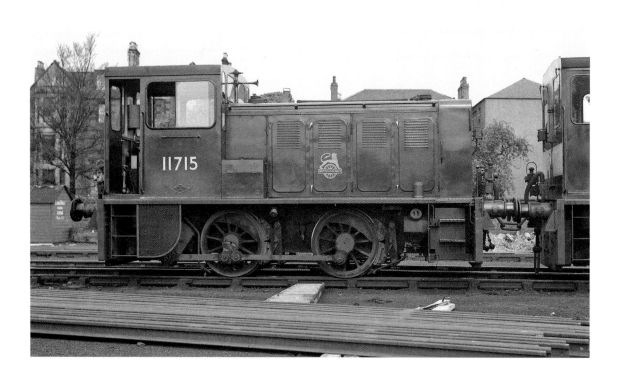

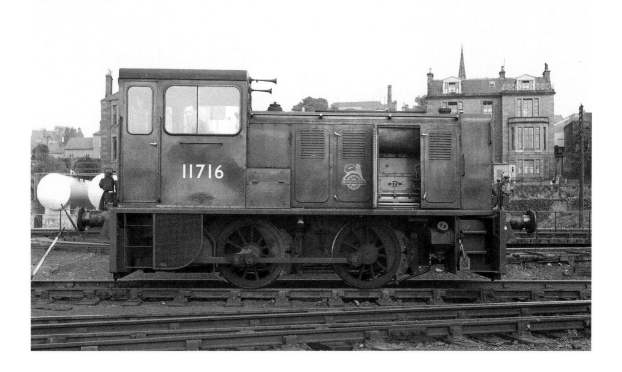

Sunday, 17 May 1959. This spread shows three examples of the NBL-constructed 0-4-0 diesel hydraulic shunter, all parked in Dundee West depot yard.

Opposite top: No. 11709, constructed in 1957, was allocated to Dundee until 1965, when it moved to the Wolverton Carriage Works. It would be withdrawn from here during 1967, numbered D2709. (Ron Buckley)

Opposite bottom: Similarly, No. 11715 was constructed during 1957 and allocated to Dundee, but it only stayed until 1963. Renumbered D2715, it then spent four years allocated to St Margaret's in Edinburgh before being withdrawn in 1967. (Ron Buckley)

Above: With the engine compartment doors open, revealing the NBL/MAN works plate attached to the engine block, No. 11716, another 1957-built example, would later become No. D2716. Allocated to Dundee until 1962, when it was transferred to Dunfermline, it would also be withdrawn during 1967. (Ron Buckley)

Above: **Sunday, 17 May 1959**. Hunslet-constructed 0-6-0 diesel mechanical shunter No. D2578 entered service during 1958 and would spend its entire working life allocated to Thornton Junction depot, where it is seen here. Withdrawn during 1967, it was purchased by cider makers Bulmer Ltd and transferred to its Hereford site, where it was given the name *Cider Queen.* Sold to the D2578 Locomotive Group in 2001, it is currently kept at former RAOC site New Moreton Business Park. (Ron Buckley)

Opposite top: **Saturday, 23 May 1959**. Entering service with BR during this week, NBL-constructed Type 2 (Class 21) No. D6112 is in ex-works condition, standing at Doncaster Works. It was initially allocated to Stratford depot but reallocated to Eastfield in Glasgow from September 1960. It would undergo rebuilding with an uprated engine and be classified Class 29, but would only see twelve years of service before being withdrawn during 1971. (Andrew Forsyth)

Opposite bottom: **Saturday, 23 May 1959**. English Electric-constructed Type 2 (Class 28) No. D5901 has also just been delivered from its manufacturer to Doncaster Works, where it is seen awaiting allocation to Hornsey depot. It would only give ten years' service before being withdrawn in 1969. (Andrew Forsyth)

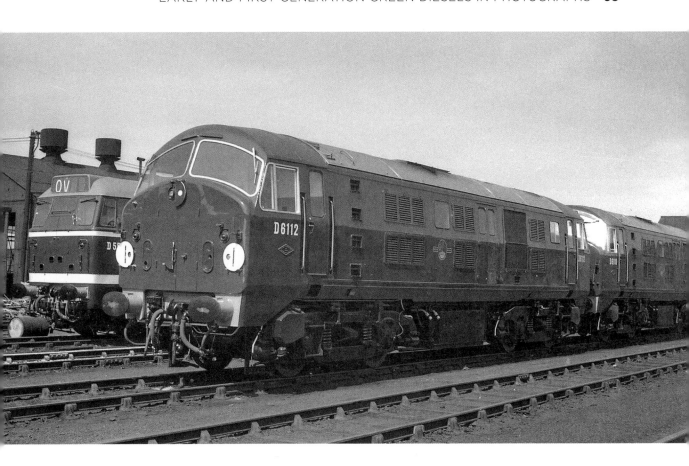

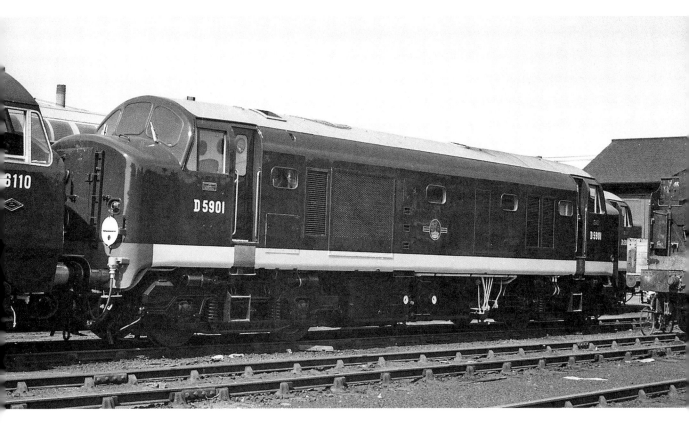

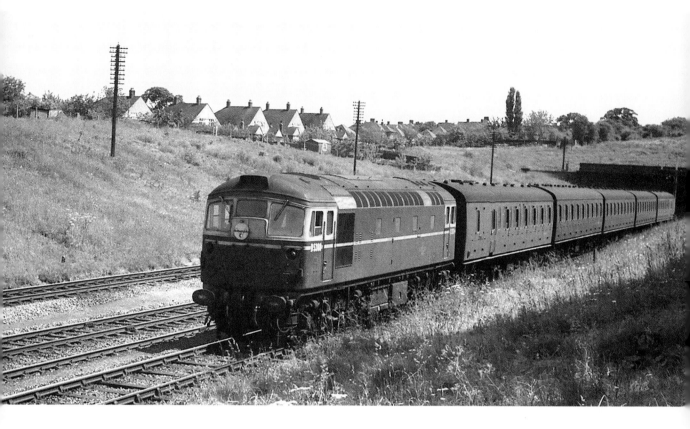

Above: **Saturday, 13 June 1959**. Seen approaching Oakleigh Park station at the head of a 'down' local working is BRC&W-constructed Type 2 (Class 26) No. D5308. Barely six months into its working life and initially allocated to Hornsey depot, it would later spend fifteen years at Haymarket in Edinburgh before finally being allocated to Inverness from 1975 after it was renumbered 26 008 in the TOPS scheme. It would be withdrawn after thirty-five years of service during 1993. (Andrew Forsyth)

Opposite top: **Sunday, 30 August 1959**. Standing in Doncaster Works yard is ex-works Brush Traction-constructed Type 2 (Class 30) No. D5546, awaiting its first allocation. Rebuilt with a new engine in 1965 it would be classified Class 31 and renumbered 31 128. Spending much of its life allocated to depots in Ipswich, March and Sheffield Darnall, it would be sold to a private buyer during 1999. It was registered for main-line work by train operator Fragonset in 2001, where it would be named *Charybdis*. It is currently believed to be working under the Nemesis Rail umbrella. (Ron Buckley)

Opposite bottom: **Sunday, 30 August 1959**. Also seen in Doncaster Works yard is newly delivered BRC&W Type 2 (Class 26) No. D5338. Briefly allocated to Haymarket in Edinburgh, it would be allocated to Inverness from 1960 and then would be withdrawn (numbered 26 038) during 1992. Purchased privately, it is based at the Scottish Railway Preservation Society's depot at Bo'ness. Note the cut-out on the cabside to enable tablet exchange equipment to be installed. (Ron Buckley)

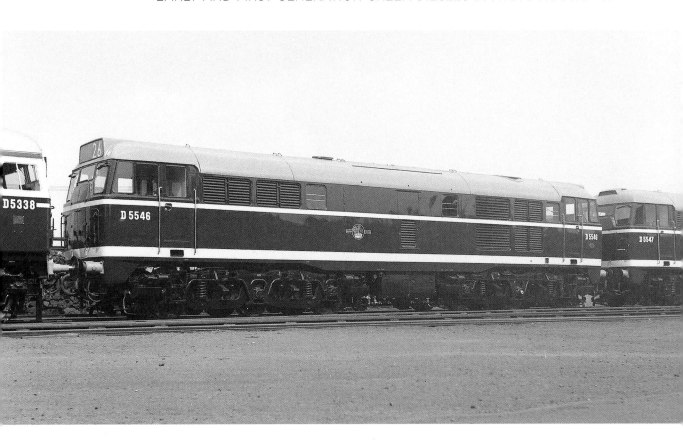

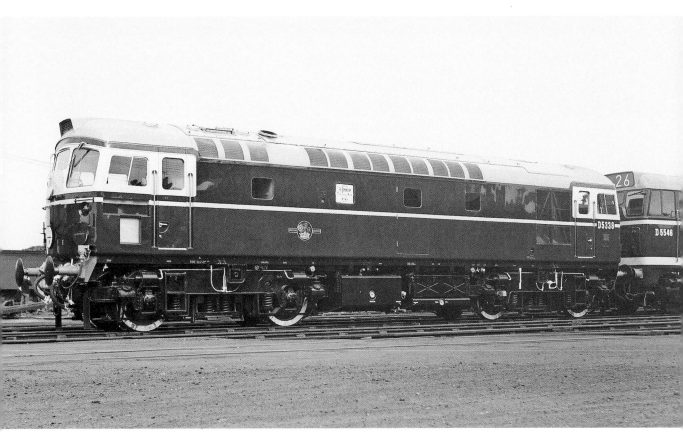

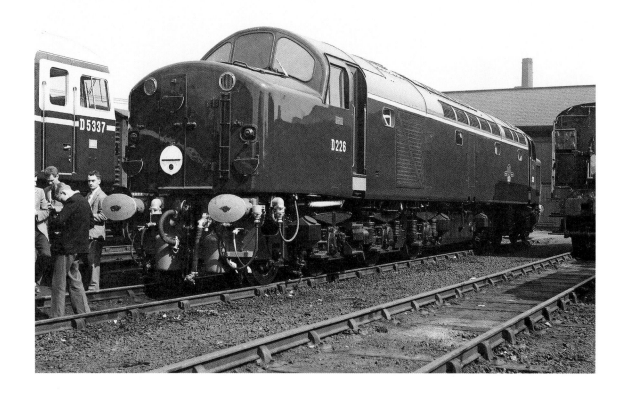

Above: **Sunday, 30 August 1959**. In ex-works condition, English Electric Type 4 (Class 40) No. D226 is waiting in Doncaster Works yard to be delivered to its first allocated depot, Camden. Renumbered 40 026 in the TOPS scheme, it would be withdrawn during 1980. (Ron Buckley)

Opposite top: **Sunday, 30 August 1959**. Also in Doncaster Works yard is English Electric Type 4 (Class 40) No. D228, having just been delivered from the Vulcan Foundry. It would be allocated to Longsight depot in Manchester and be numbered 40 028 in the TOPS scheme. During 1962 it would acquire the name *Samaria*, after the Cunard liner of the same name, and be withdrawn from service in 1984. (Ron Buckley)

Opposite bottom: **Thursday, 15 October 1959**. Standing in Derby Works yard is the second example of the Derby Works-constructed BR/Sulzer Type 4 (Class 44) No. D2 *Helvellyn*. Initially allocated to Camden depot, it would be renumbered 44 002 before being withdrawn in 1979. (Ron Buckley)

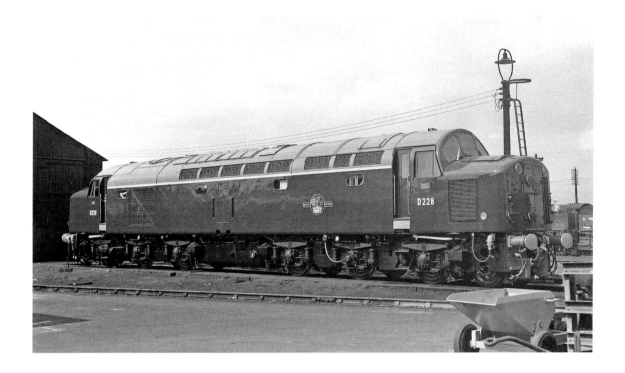

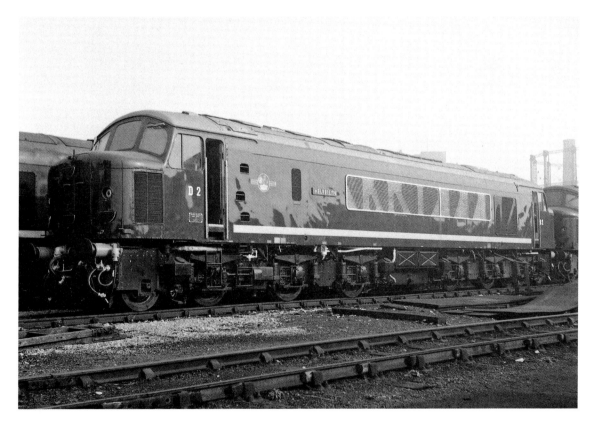

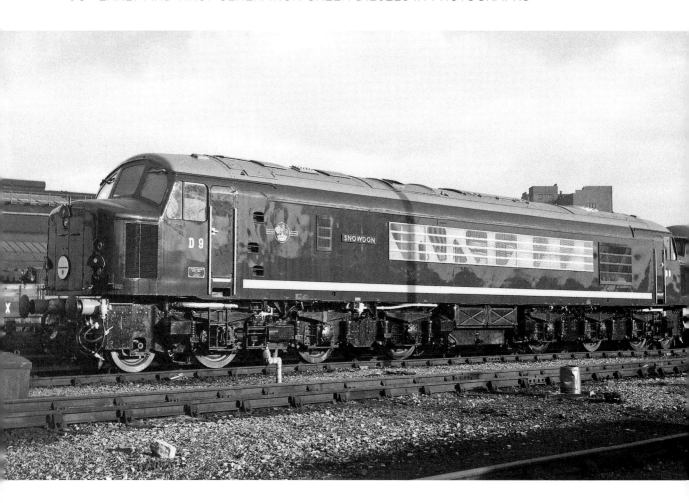

Above: **Monday, 11 January 1960**. Another newly constructed BR/Sulzer Type 4 (Class 44) is here in Derby Works yard. No. D9 *Snowdon* exited the works a week earlier and was destined to be something of a wanderer: allocated to Derby, Camden, Edge Hill, Toton and the Nottingham area over a period of nineteen years, it would be withdrawn from service during 1979, numbered 44 009. (Ron Buckley)

Opposite top: **Sunday, 20 March 1960**. Standing in Swindon Works yard is a rather forlorn-looking ex-GWR Railcar No. W15W minus its engines. Having been constructed by the GRC&W during 1936, it had been withdrawn in 1959. (Ron Buckley)

Opposite bottom: **Sunday, 20 March 1960**. In contrast to the previous photograph, ex-GWR Railcar No. 4 is in beautifully restored condition as it waits to be delivered to the National Railway Museum in York from Swindon Works. Constructed by AEC, with bodywork by Park Royal Coachbuilders, it had been withdrawn from service during 1958. (Ron Buckley)

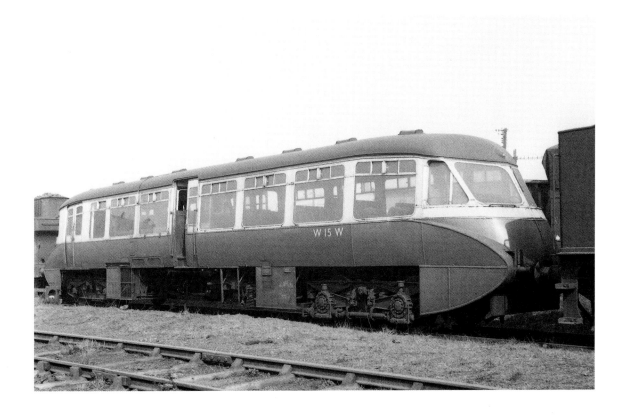

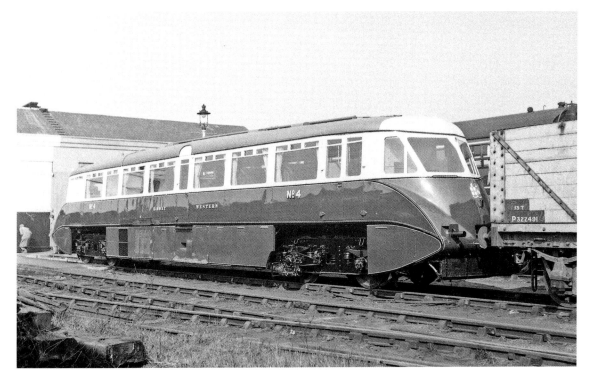

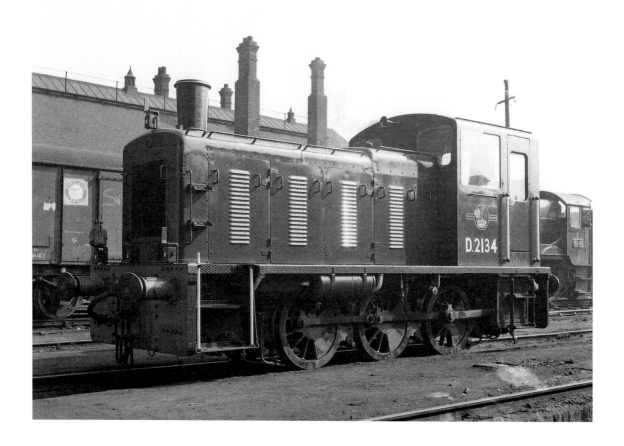

Sunday, 20 March 1960. This spread shows three consecutively numbered, ex-works, Swindon-constructed 0-6-0 diesel mechanical shunters that eventually formed part of Class 03.

Above: No. D2134 would become 03 134 in the TOPS scheme before being withdrawn during 1976. It was to be sold abroad for scrap, but instead found its way to Zeebrugge in Belgium, where it assisted in the construction of the harbour extension. It was at the Stoomcentrum at Maldegem in 1989, but had returned to the UK in 1995 and made its way into the preservation scene. It is currently based at the Royal Deeside Railway. (Ron Buckley)

Opposite top: No. D2135 would become 03 135 in the TOPS scheme and end its working life based at depots in East Anglia. It would also be withdrawn in 1976. (Ron Buckley)

Opposite bottom: No. D2136 would spend time allocated to Bristol Bath Road and Worcester depots before being withdrawn during 1972. (Ron Buckley)

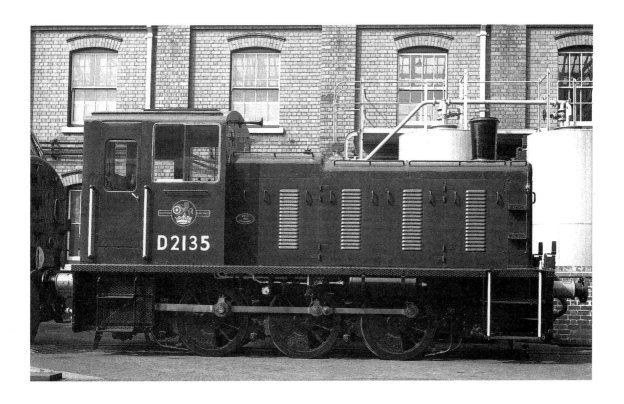

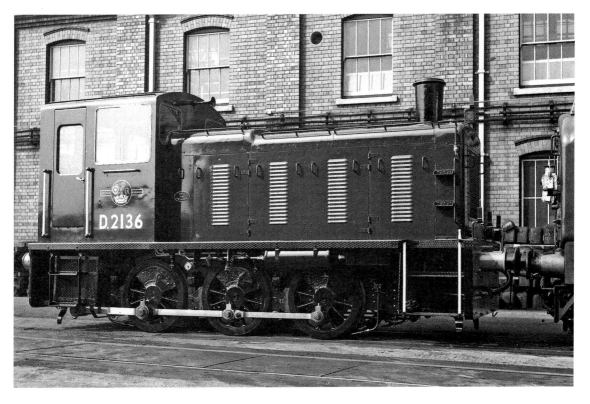

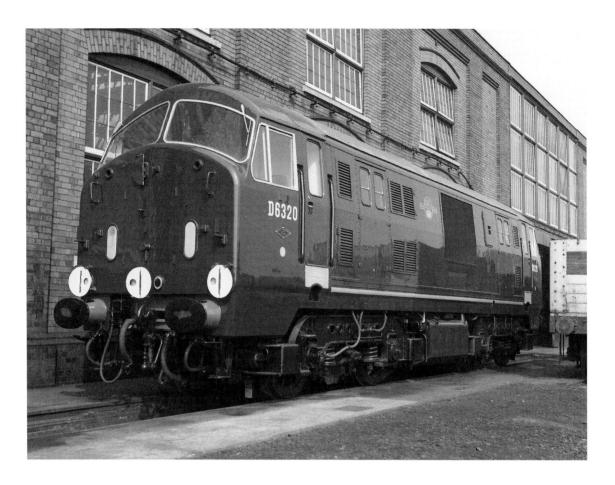

Above: **Sunday, 20 March 1960**. Having just been delivered to Swindon Works from the NBL Works in Glasgow, diesel hydraulic Type 2 (Class 22) No. D6320 would be allocated to Laira depot. It would end its days at Bristol Bath Road depot, where it would be withdrawn in 1971. (Ron Buckley)

Opposite top: **Sunday, 20 March 1960**. Also seen in Swindon Works yard is 0-6-0 diesel mechanical shunter No. D2087. Constructed at Swindon a year earlier, it would be withdrawn during 1971. (Ron Buckley)

Opposite bottom: **Sunday, 10 April 1960**. NBL-constructed diesel electric Type 2 (Class 21) No. D6124 is seen here at March depot. Initially allocated to Ipswich depot, it would quickly find itself based at Eastfield in Glasgow, before being re-engined during 1967 and classified Class 29. It would be withdrawn from service in 1971. (Ron Buckley)

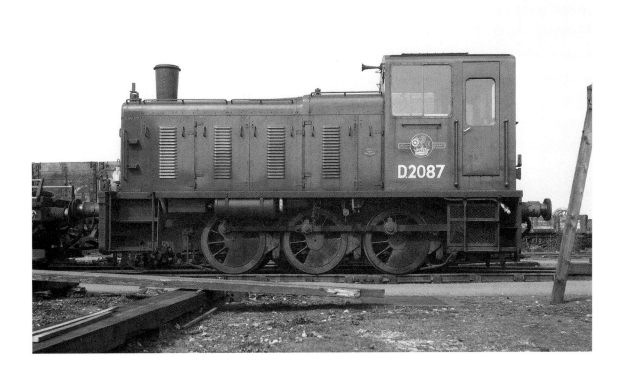

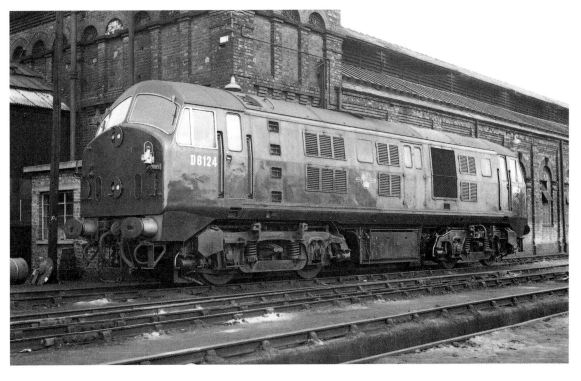

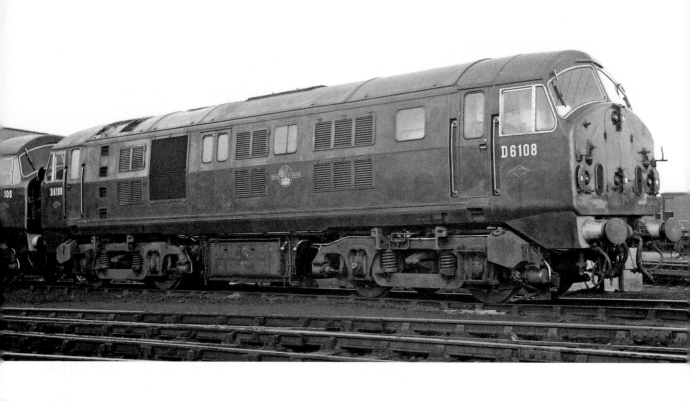

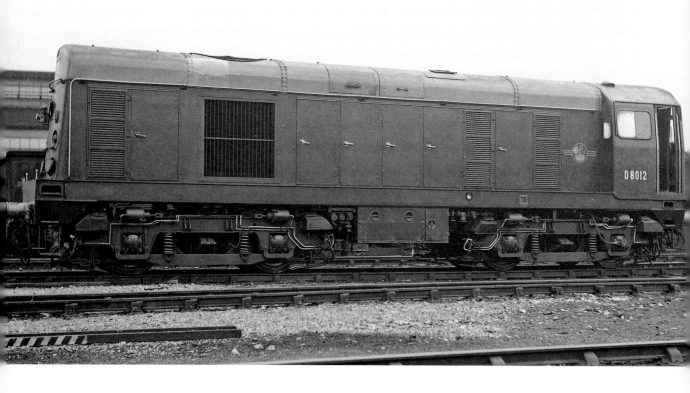

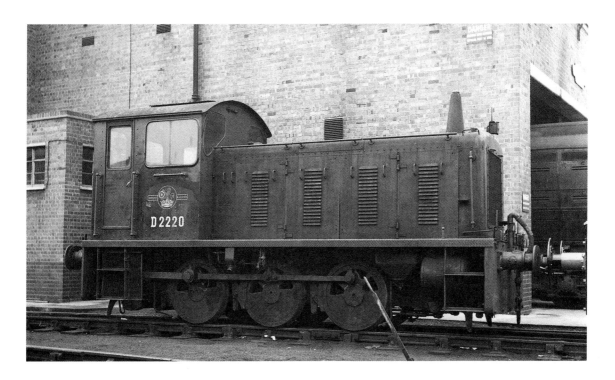

Opposite top: **Sunday, 10 April 1960**. In New England depot yard, NBL Type 2 (Class 21) No. D6108 is most likely on its return to Scotland, having been rejected by the Eastern Region as unsuitable for traffic. Entering service a year earlier, it was initially allocated to Hornsey depot, but by late April 1960 was working out of Eastfield depot in Glasgow. It would be re-engined during 1967 and classified Class 29, but it would be withdrawn during 1969, giving only ten years of service. (Ron Buckley)

Opposite bottom: **Wednesday, 13 April 1960**. Derby Works yard sees visiting English Electric Type 2 (Class 20) No. D8012. Constructed at the Vulcan Foundry during 1957, it would be renumbered 20 012 in the TOPS scheme and withdrawn in 1976. (Ron Buckley)

Above: **Wednesday, 13 April 1960**. Also in Derby Works yard is 0-6-0 diesel mechanical shunter No. D2220. Delivered in 1955 from the Drewry Car Co. and originally numbered 11126, it was first allocated to Eastern Region depots but would be withdrawn from service during 1968, whilst based at Bescot. (Ron Buckley)

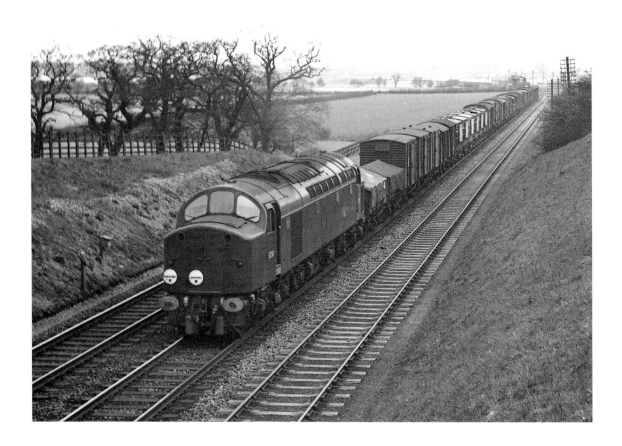

Above: **Saturday, 16 April 1960**. Near Gamston in Nottinghamshire, English Electric Type 4 No. D258 is seen working an 'up' goods. Constructed at the Vulcan Foundry and entering service only a few months earlier, it would be renumbered 40 058 in the TOPS scheme and be withdrawn during 1984. (Ron Buckley)

Opposite top: **Sunday, 1 May 1960**. Seen in Stratford depot yard, NBL Type 1 No. D8401 entered service during 1958 and would be based at Stratford for its entire working life, being withdrawn during 1968. (Ron Buckley)

Opposite bottom: **Sunday, 4 September 1960**. In a derelict state in Southall depot yard, ex-GWR Parcels Railcar No. W34W has already had its engines removed. Constructed at Swindon Works during 1941, it had been withdrawn from service during this same month. (Ron Buckley)

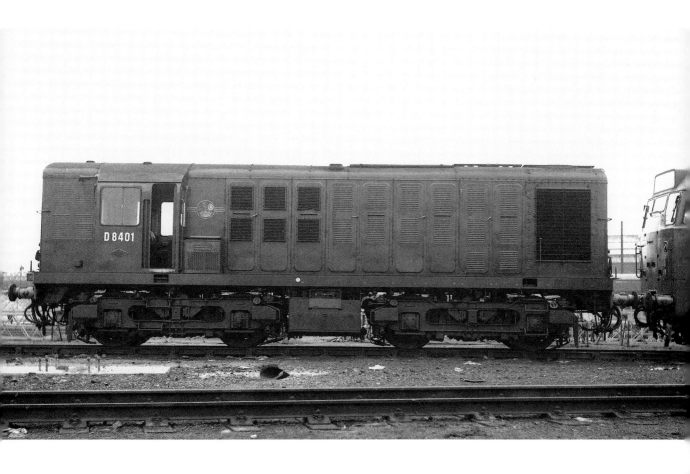

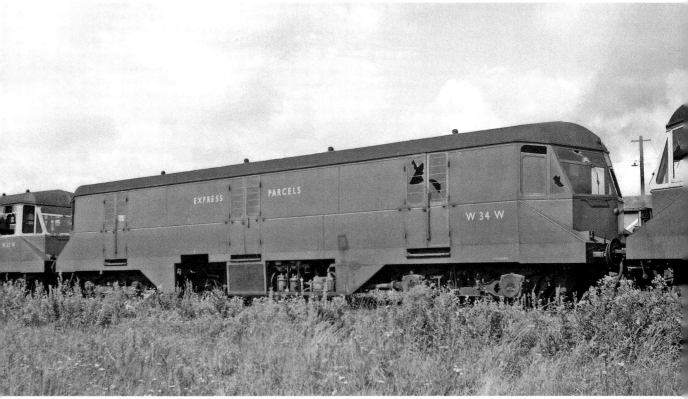

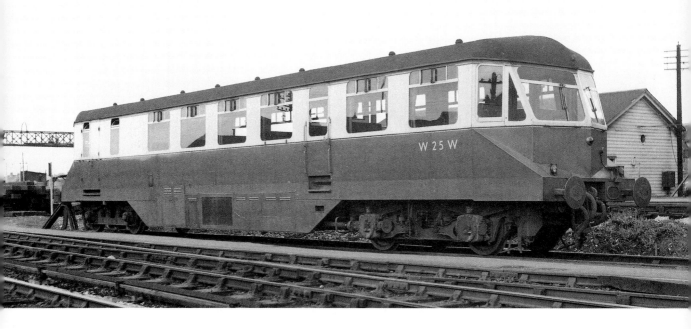

Above: **Sunday, 4 September 1960**. Also seen in Southall depot yard is ex-GWR Railcar No. W25W. Constructed at Swindon Works in 1940, it would be withdrawn from service two years after this photograph was taken. (Ron Buckley)

Opposite top: **Tuesday, 18 October 1960**. In Derby Works yard is the first example of the second series of 'Peak' locomotives. BR/Sulzer Type 4 (Class 45) No. D11 is fresh out of the works and has been fitted with a split four-digit route indicator; numbered 45 122 in the TOPS scheme, it would spend its final fifteen years allocated to Toton, from where it would be withdrawn during 1987. (Ron Buckley)

Opposite bottom: **Monday, 14 November 1960**. Also seen in Derby Works yard is a further example of the BR/Sulzer Type 4 (Class 45). No. D68 was constructed at Crewe Works and entered service a month earlier. Named *Royal Fusilier* in 1967, it would be renumbered 45 046 in the TOPS scheme and be withdrawn from service during 1988. (Ron Buckley)

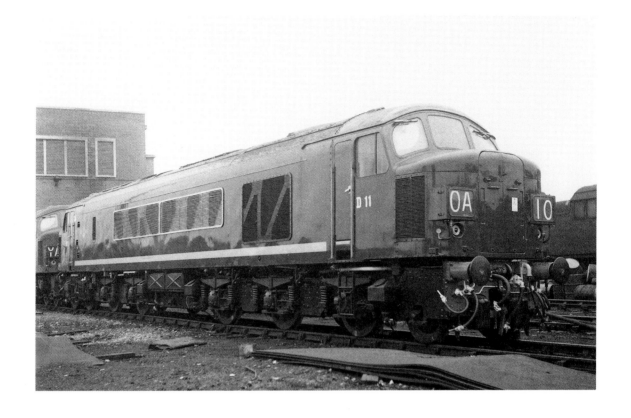

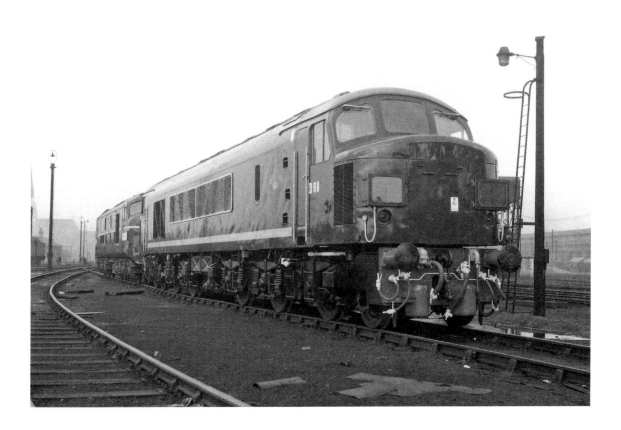

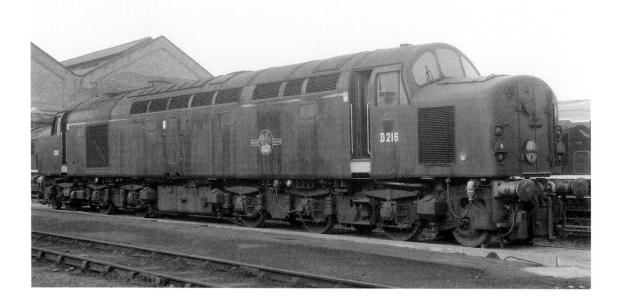

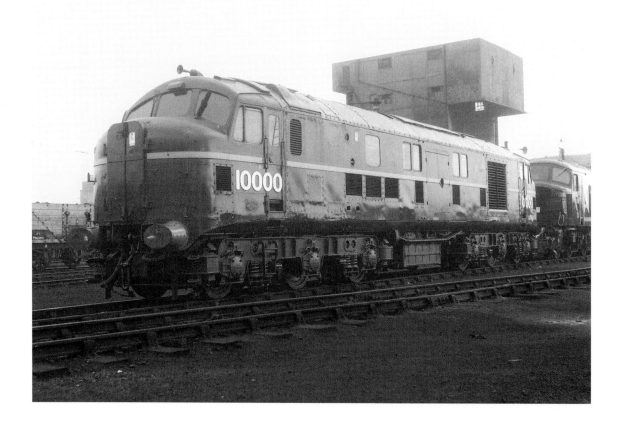

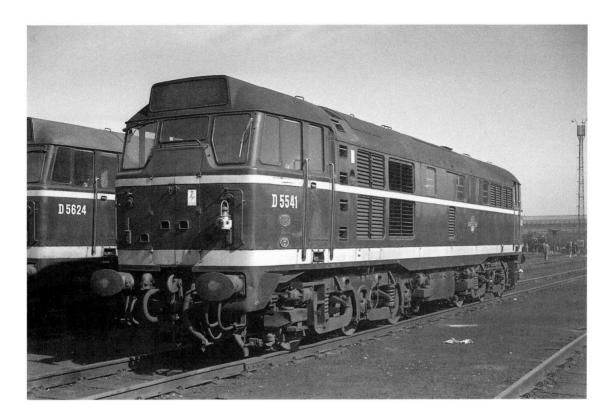

Opposite top: **Monday, 14 November 1960**. Having entered service in June 1959, English Electric Type 4 (Class 40) No. D216 is looking rather grimy. Seen here standing in Derby Works yard, at this time it was allocated to Carlisle Upperby. Acquiring the name *Campania* (after the Cunard liner) in 1962, it would be withdrawn during 1981, numbered 40 016. (Ron Buckley)

Opposite bottom: **Monday, 14 November 1960**. Standing in Derby shed yard, wearing green livery, is No. 10000. Spending much of its time at this period working goods trains, it would be withdrawn from service during 1963. The Ivatt Diesel Recreation Society currently have plans, titled 'Project Icon', to build a replica. (Ron Buckley)

Above: **Saturday, 26 March 1961**. Standing in Stratford depot yard bearing a 32A shed code is Brush Traction Type 2 (Class 30) No. D5541. Entering service during 1959 and allocated to Ipswich depot, it would be re-engined and classified Class 31 in 1965. Numbered 31 123 in the TOPS scheme, it would be withdrawn during 1992 and sold to a private buyer; it appears to have been operational at the Gloucester and Warwickshire Railway for some time but had been sold for scrap by 2006. (Hugh Ramsay)

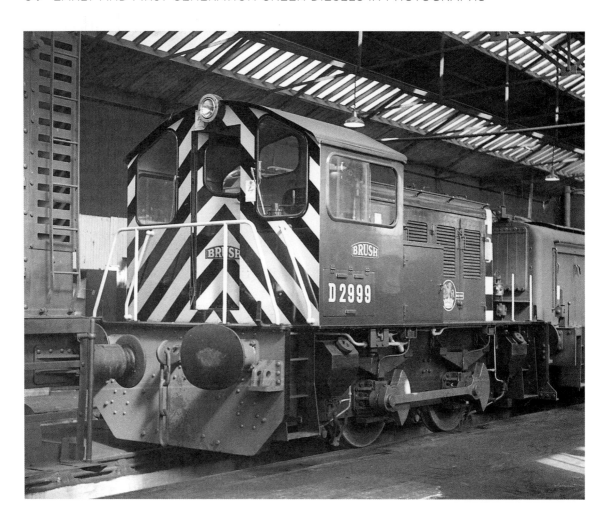

Above: **Saturday, 26 March 1961**. Sitting in Stratford diesel depot is 0-4-0 diesel electric shunter No. D2999. Of a total of five locomotives that were constructed by Beyer Peacock & Co. and fitted with Brush Traction electrical equipment, this was the only example purchased by BR, which it was in 1960. Based at Stratford for its entire working life, it would be withdrawn during 1967. (Hugh Ramsay)

Opposite top: **Sunday, 9 April 1961**. In Swindon Works yard is NBL-constructed diesel hydraulic Type 4 (Class 43) No. D841 *Roebuck*. It had entered service five months earlier, having been allocated to Laira depot, but would only give eleven years of service before being withdrawn during 1971. (Hugh Ramsay)

Opposite bottom: **Sunday, 9 April 1961**. Seen in Swindon Works yard, having been constructed there only four months earlier, 0-6-0 diesel mechanical shunter No. D2143 would see service based at Swindon, Worcester and Landore depots before being withdrawn during 1968. (Hugh Ramsay)

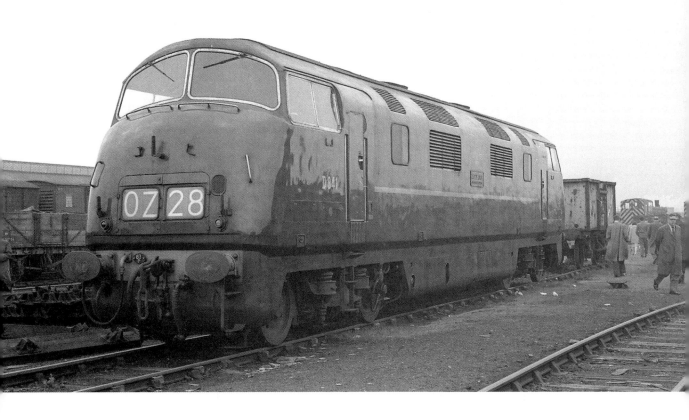

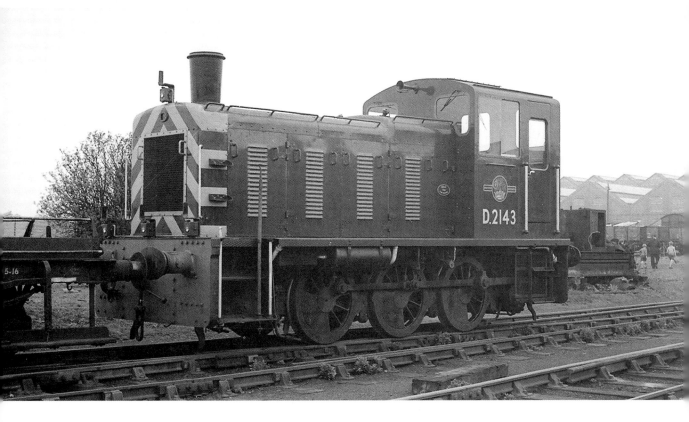

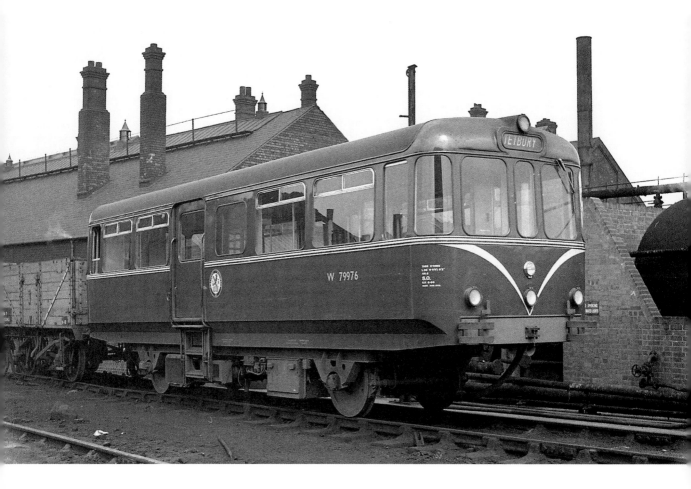

Sunday, 9 April 1961. In contrast to the earlier art deco railcars of the GWR, this utilitarian-looking rail bus No. W79976 was constructed by A.C. Cars and entered service during September 1958. Allocated to the Western Region until 1967, when it moved to Scotland, it would be withdrawn in 1968. (Hugh Ramsay)

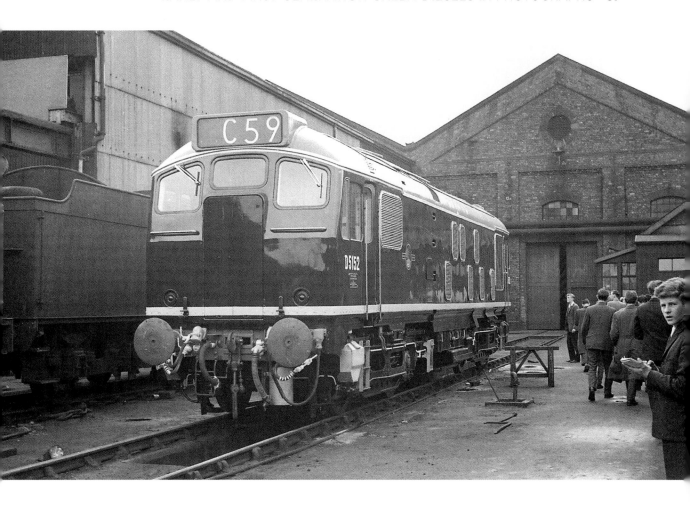

Sunday, 23 April 1961. Standing outside Darlington Works is newly constructed BR/Sulzer Type 2 (Class 25) No. D5152. Initially allocated to Thornaby depot, it would end its days based at Eastfield in Glasgow, numbered 25 002 under the TOPS scheme, before being withdrawn during 1980. (Hugh Ramsay)

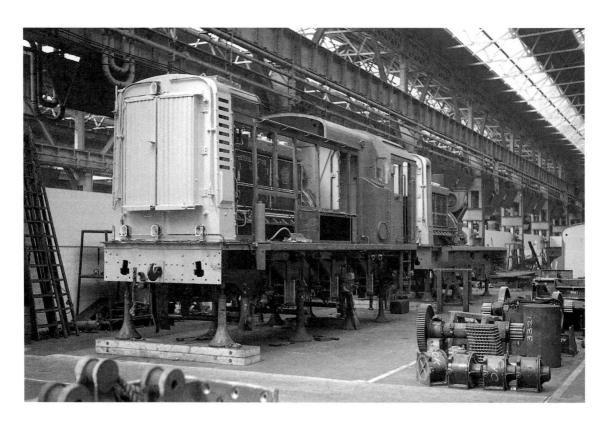

Above: **Sunday, 23 April 1961**. Inside Darlington Works' erecting shop, a 350hp 0-6-0 diesel electric shunter is under construction. Incorporating a Lister Blackstone engine, it is yet to be united with its wheel sets, while chalked on the side of the running board is the number 4068. D4068 would enter service early in May of that year and be withdrawn during 1972, after which it would be sold to the National Coal Board to work at Whittle Colliery in Northumberland, until it was scrapped in 1985. (Hugh Ramsay)

Opposite top: **Wednesday, 5 July 1961**. Still in virtually ex-works condition, having entered service the previous month, English Electric Type 4 (Class 40) No. D349 is displaying the four-digit route indicator style that was fitted to the later members of the class. Seen here near New Southgate station at the head of an 'up' fitted goods train, it would be allocated to Gateshead depot during the 1970s and be withdrawn from service in 1981, numbered 40 149. (Hugh Ramsay)

Opposite bottom: **Sunday 16 July 1961**. Standing in Doncaster Works yard, newly delivered from Brush Traction at Loughborough, is Brush Type 2 (Class 30) No. D5806. It would receive a new engine during 1967 and be classified Class 31. Numbered 31 276, it wouldn't be withdrawn from service until 2000. (Ron Buckley)

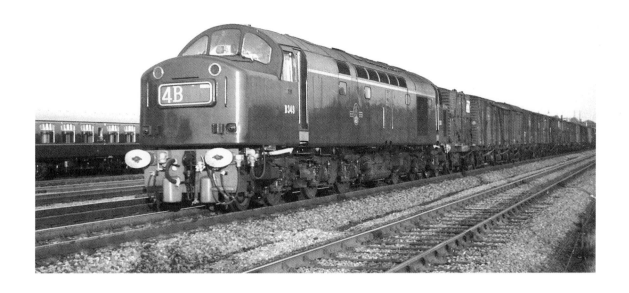

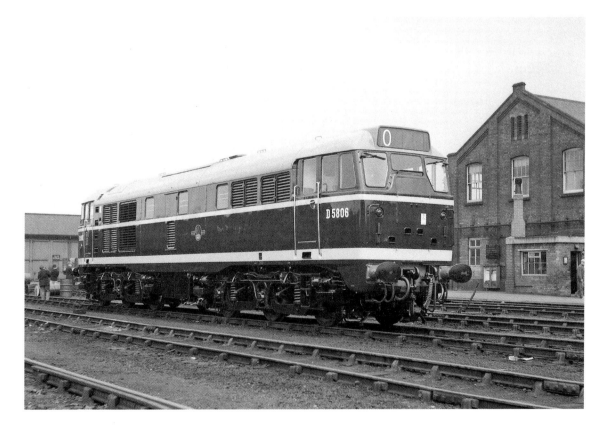

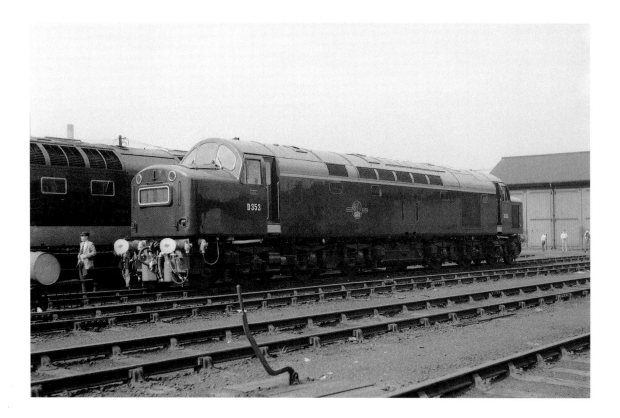

Above: **Sunday, 16 July 1961**. Also in Doncaster Works yard is newly delivered English Electric Type 4 (Class 40) No. D353. Allocated to Gateshead depot from 1969, it would be renumbered 40 153 in the TOPS scheme and be withdrawn during 1983. (Ron Buckley)

Opposite top: **Sunday, 7 January 1962**. Due to Sunday diversions, the 9.18 a.m. Bradford to London St Pancras working is seen passing Eckington station with BR/Sulzer Type 4 (Class 45) No. D98 at its head. Constructed at Crewe Works during 1961, it would acquire the name *Royal Engineer* in 1966, be numbered 45 059 in the TOPS scheme, and be withdrawn during 1986. (Ron Buckley)

Opposite bottom: **Sunday, 7 January 1962**. Similarly diverted to the Great Central route near Eckington station is the 9.35 a.m. Bradford to Bristol working. In charge is BR/Sulzer Type 4 (Class 45) No. D27, which was constructed at Derby Works during 1961. Under the TOPS scheme it would be renumbered 45 028 before being withdrawn in 1981. (Ron Buckley)

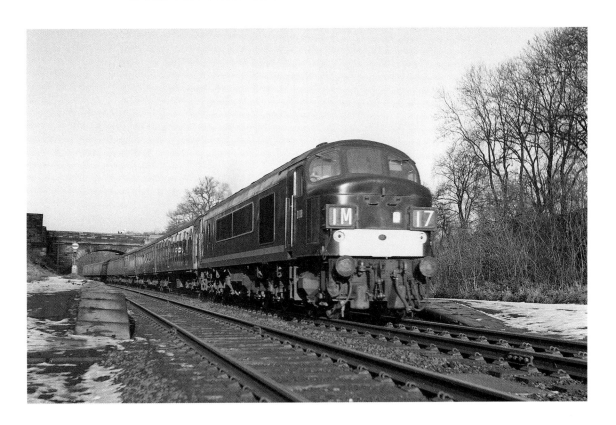

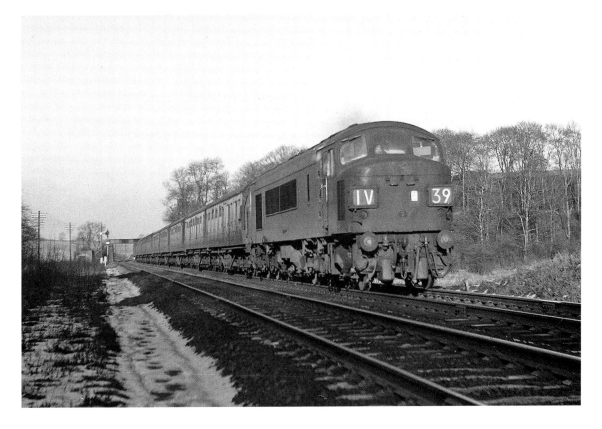

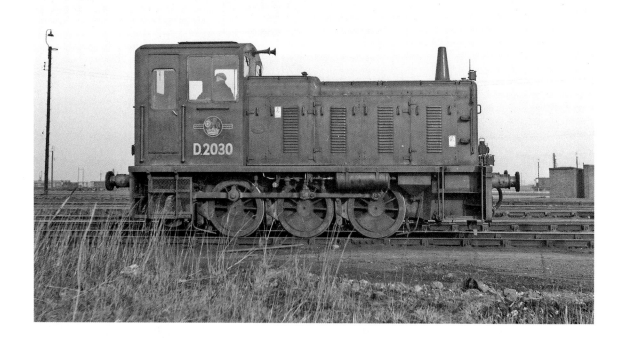

Above: **Saturday, 20 January 1962**. Constructed at Swindon Works during 1958, 0-6-0 diesel mechanical shunter No. D2030 is seen standing in March yard. It would only give eleven years of service, being withdrawn in 1969. (Ron Buckley)

Opposite top: **March 1962**. Approaching Oakleigh Park station at the head of an 'up' semi-fast working is Brush Traction Type 2 (Class 30) No. D5646. Entering service during 1960 from their Loughborough Works, it would be allocated to Finsbury Park depot and remain there until 1988, when it moved to Crewe. Classified Class 31 after being re-engined during 1966, it would be withdrawn from service in 2001, numbered 31 408. (Andrew Forsyth)

Opposite bottom: **March 1962**. Also seen approaching Oakleigh Park station at the head of the 7.30 a.m. express from Leeds to London Kings Cross (1A03) is English Electric Type 5 (Class 55) No. D9008. Having entered service less than a year earlier, it had been allocated to Gateshead depot. It was named *The Green Howards* during 1963, and would be renumbered 55 008 in the TOPS scheme before being withdrawn in 1981. One of the driving cabs was saved and is fitted out for computer-simulated driving. (Andrew Forsyth)

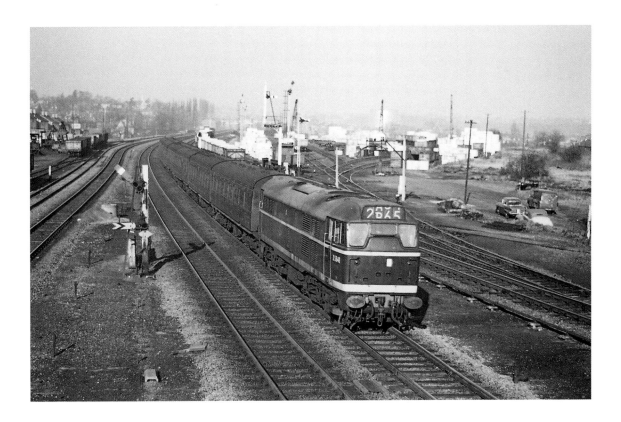

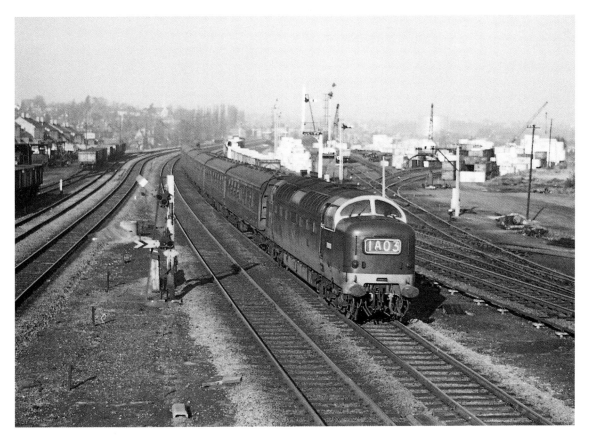

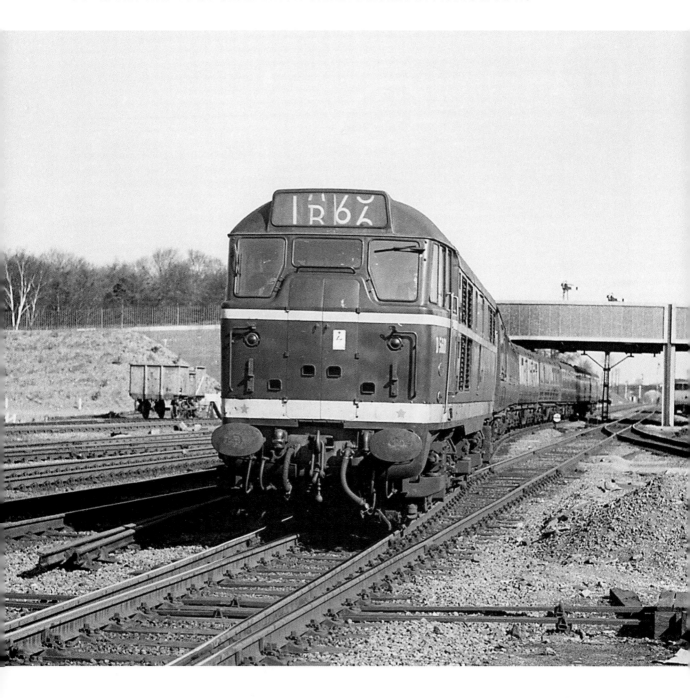

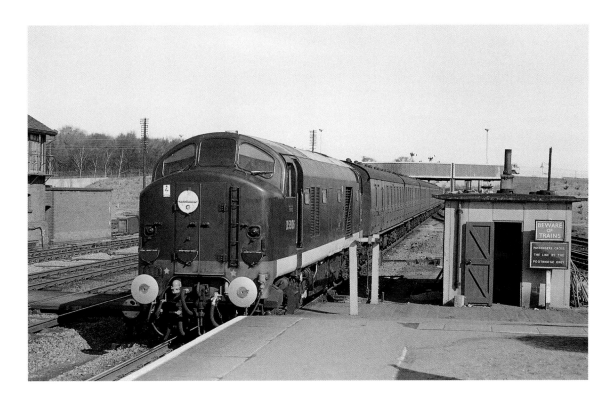

Opposite: **March 1962**. Seen entering Welwyn Garden City station at the head of an 'up' express working is Brush Traction Type 2 (Class 30) No. D5601. Constructed at Loughborough during 1960, it would be re-engined and reclassified Class 31 in 1965. Renumbered 31 180, it would be withdrawn from service during 2000. (Andrew Forsyth)

Above: **March 1962**. Also seen at Welwyn Garden City station is English Electric Type 2 (Class 23) No. D5906 working an 'up' local. Entering service during 1959 the class of only ten locomotives constructed were troublesome and all were withdrawn by 1968. (Andrew Forsyth)

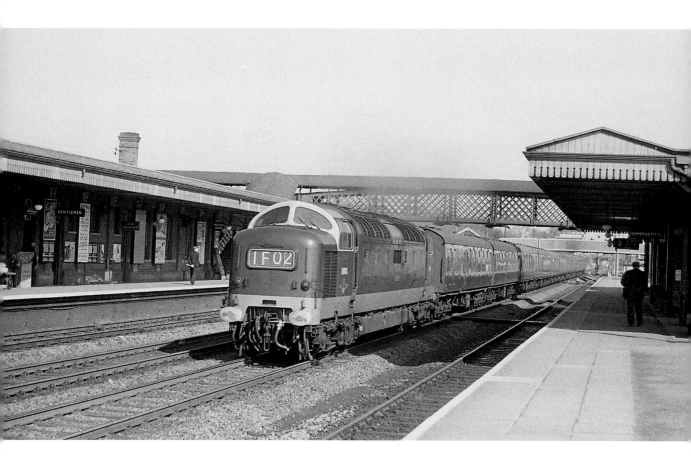

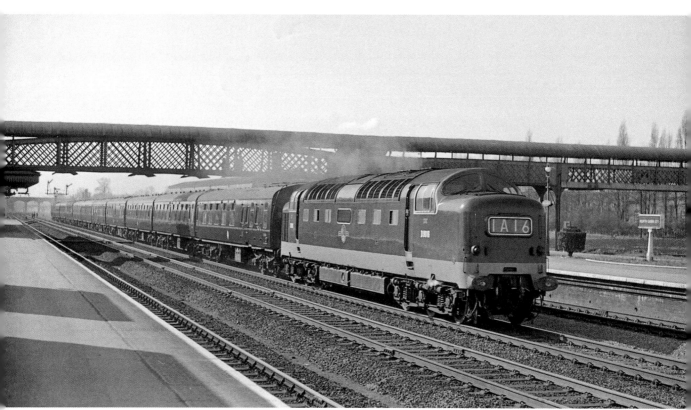

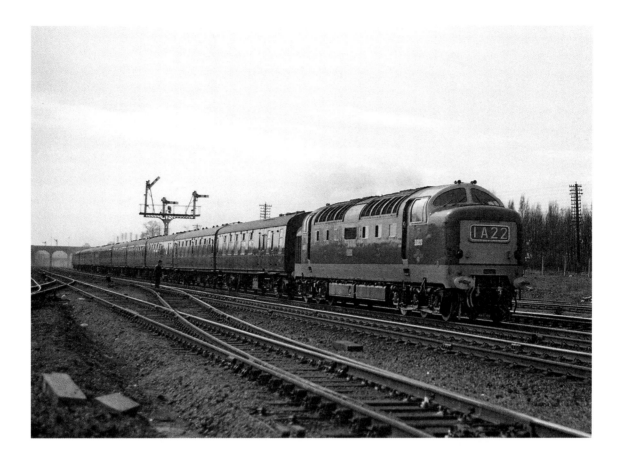

March 1962. A trio of English Electric Type 5 (Class 55) 'Deltics' are seen here at Welwyn Garden City station.

Opposite top: No. D9015 *Tulyar* is working an 'up' special passenger train. Entering traffic during 1961 and based at Finsbury Park depot, it would be numbered 55 015 in the TOPS scheme before being withdrawn in 1982. It is now owned by the Deltic Preservation Society and is currently undergoing a major overall at its Barrow Hill depot. (Andrew Forsyth)

Opposite bottom: No. D9016 *Gordon Highlander* is working a 'down' passenger train. Entering service in 1961, based at Haymarket in Edinburgh, it was named at a ceremony in Aberdeen during 1964. It would be numbered 55 016 and be withdrawn during 1981. It was then purchased privately: ownership has changed several times and it is currently owned by a private buyer. (Andrew Forsyth)

Above: No. D9020 *Nimbus* is working a 'down' express. After entering service during 1962, it would be based at Finsbury Park. Numbered 55 020 in the TOPS scheme, it would be withdrawn in 1980. (Andrew Forsyth)

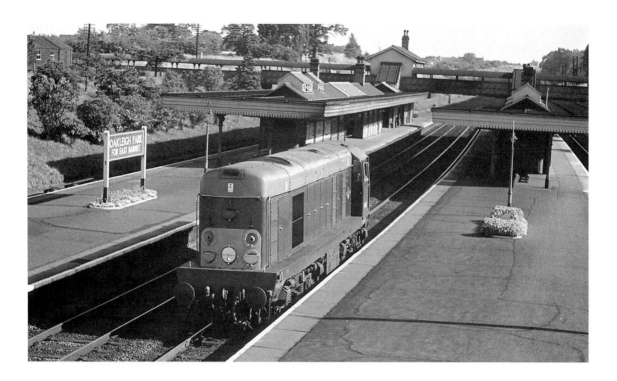

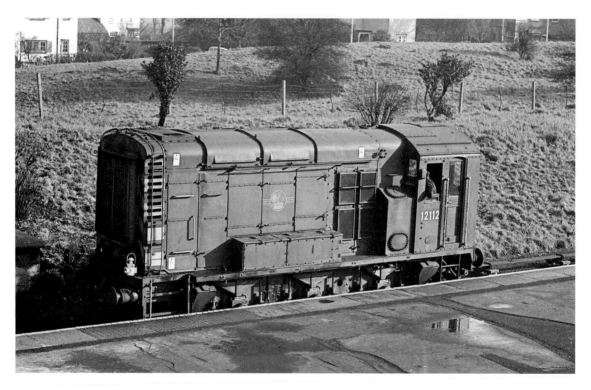

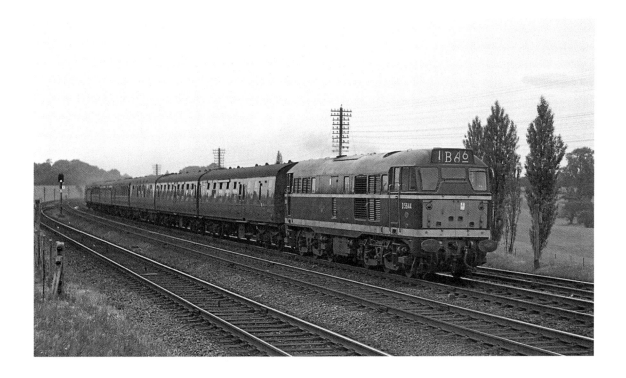

Opposite top: **March 1962**. This unidentified English Electric Type 1 (Class 20) is seen drifting through Oakleigh Park station. (Andrew Forsyth)

Opposite bottom: **March 1962**. Another light engine working sees 0-6-0 diesel electric shunter No. 12112 moving through Oakleigh Park station. Constructed at Darlington Works during 1952, it would be based at Hornsey, Kings Cross and Finsbury Park depots before ending its days at Saltley, where it was withdrawn from service in 1969. (Andrew Forsyth)

Above: **March 1962**. Seen at the head of an 'up' express passenger working near Potters Bar station is Brush Traction Type 2 (Class 30) No. D5644. Entering service during 1960, it would be allocated to Finsbury Park depot for its entire working life, it would be re-engined and reclassified Class 31 in 1966. It would be numbered 31 219 on the TOPS scheme and wouldn't be withdrawn until 2000. (Andrew Forsyth)

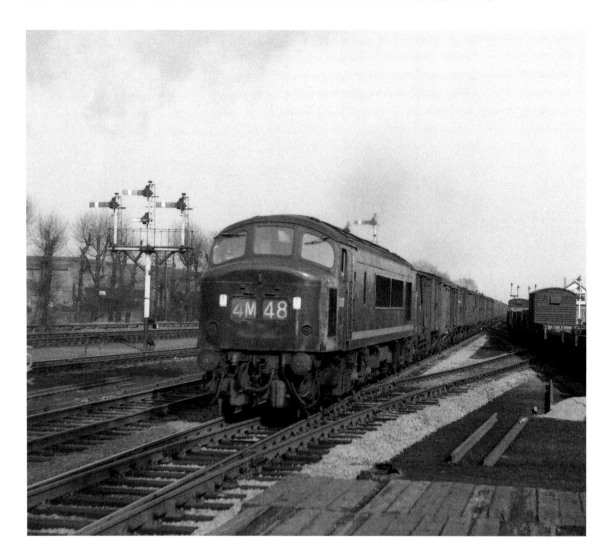

Saturday, 17 March 1962. Seen at the head of a 'down' goods approaching Castle Bromwich station is BR/Sulzer Type 4 (Class 45) No. D127, barely four months out of Crewe Works. It would be renumbered 45 072 in the TOPS scheme and be withdrawn during 1985. (Ron Buckley)

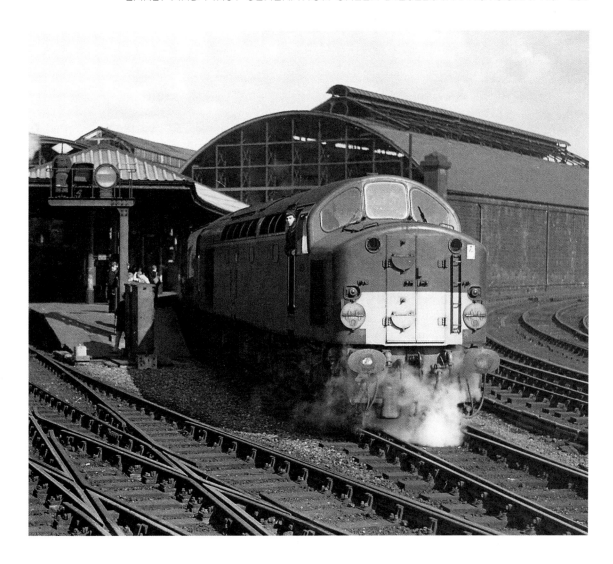

Friday, 23 March 1962. English Electric Type 4 (Class 40) No. D285 is waiting to depart from Newcastle Central station with an 'up' working. Constructed at the Vulcan Foundry during 1960, it would be allocated to only two depots throughout its working life: Gateshead and York. Renumbered 40 085, it would be withdrawn in 1984. (Andrew Forsyth)

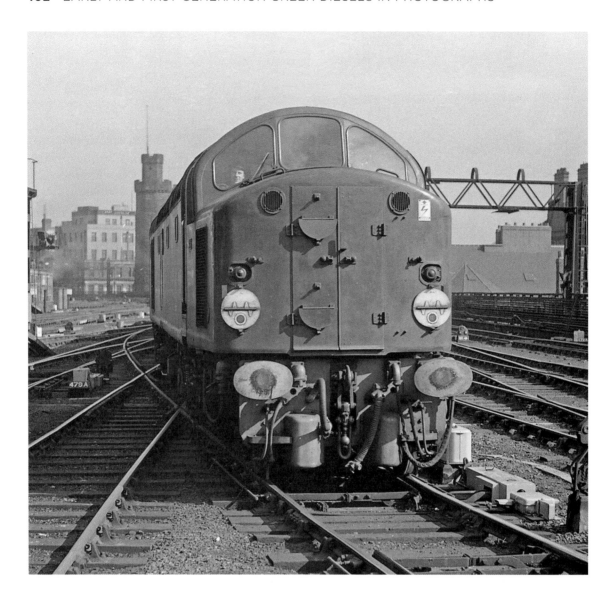

Above: **Friday, 23 March 1962**. This unidentified English Electric Type 4 (Class 40) is gently leaning its 133 tons into Newcastle Central station at the head of a 'down' working. (Andrew Forsyth)

Opposite top: **Friday, 23 March 1962**. Another English Electric Type 4 (Class 40) No. D240 is accelerating past the former York Racecourse station at the head of an 'up' express. Entering service in 1959 from the Vulcan Foundry, it would be withdrawn from service twenty years later, numbered 40 040. (Andrew Forsyth)

Opposite bottom: **Friday, 23 March 1962**. Bearing a 52A Gateshead shed code, BR/ Sulzer Type 4 (Class 45) No. D24 is seen passing the former York Racecourse station at the head of a Bristol-bound express. Constructed at Derby Works during 1961, it would become 45 027 in the TOPS scheme before being withdrawn in 1981. (Andrew Forsyth)

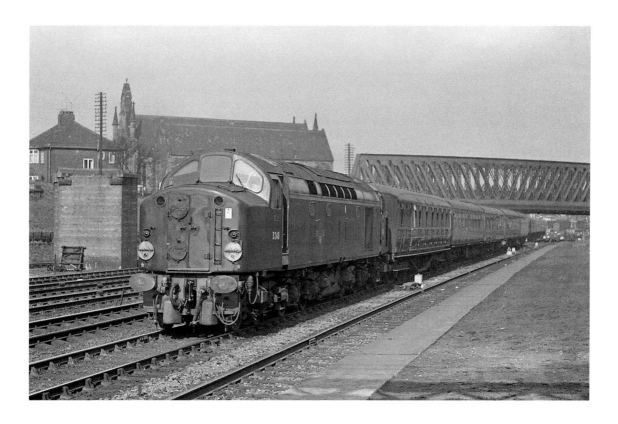

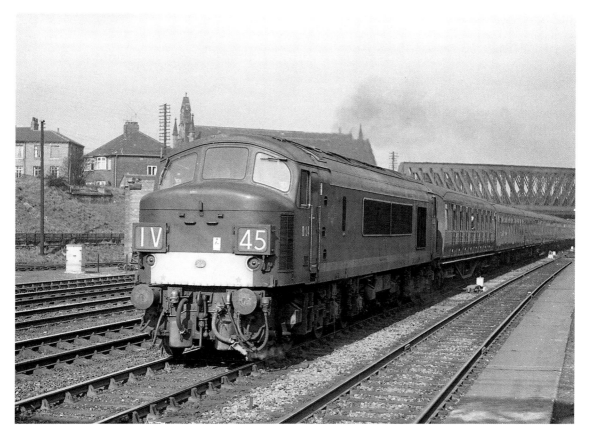

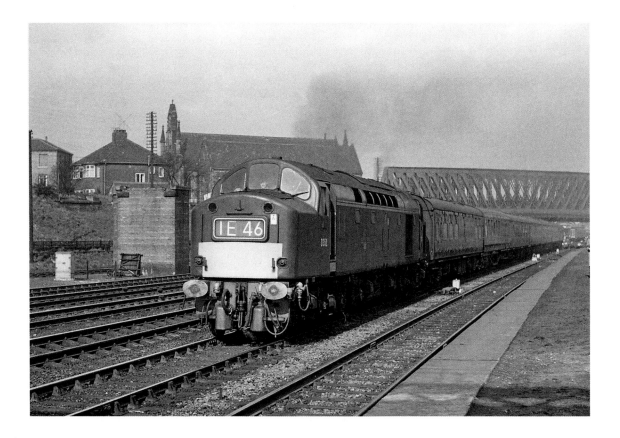

Above: **Friday, 23 March 1962**. At the former York Racecourse station again, English Electric Type 4 (Class 40) No. D352 is at the head of an 'up' express. Constructed at the Vulcan Foundry during 1961, it would be renumbered 40 152 and be withdrawn in 1985. (Andrew Forsyth)

Opposite top: **April 1962**. Approaching Oakleigh Park station on the 'up' slow line, with Hadley Wood South tunnel in the background, is Brush Traction Type 2 (Class 30) No. D5683. Entering service in 1961, it would be allocated with depots at Sheffield Darnall, Finsbury Park, March, Tinsley, Saltley, Stratford and finally Bescot. Re-engined and reclassified Class 31 during 1966 and numbered 31 255 under the TOPS scheme, it would be withdrawn in 1999 and sold to the Colne Valley Diesel Group.

 The train in the photograph is 6B62, the returning empty 'bins' (rubbish train) from Blackbridge sidings to Ashburton Grove, Finsbury Park. (Andrew Forsyth)

Opposite bottom: **April 1962**. Entering Oakleigh Park station at the head of a 'down' express is English Electric Type 4 (Class 40) No. D201. The second example of this class to enter service during 1958, it would be numbered 40 001 in the TOPS scheme before being withdrawn in 1984. (Andrew Forsyth)

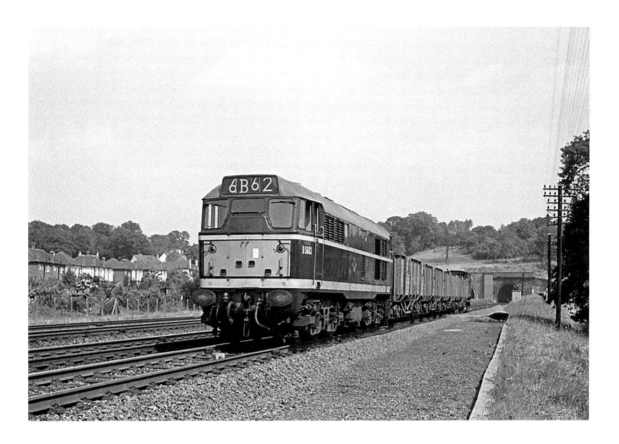

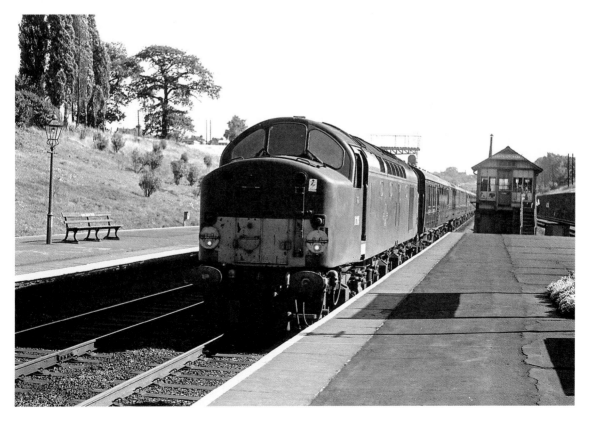

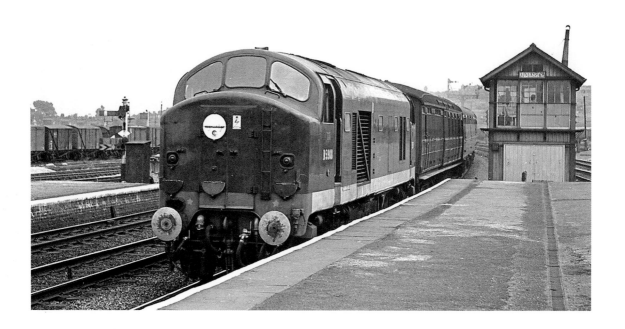

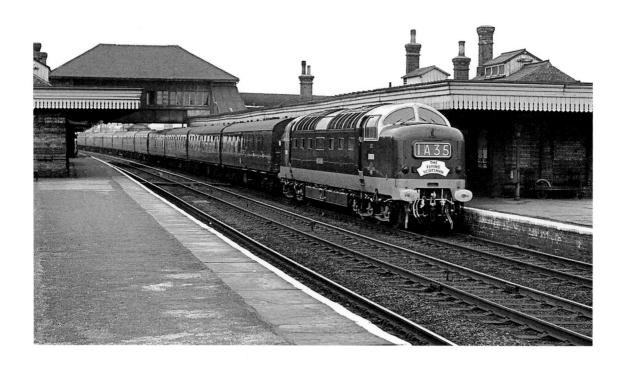

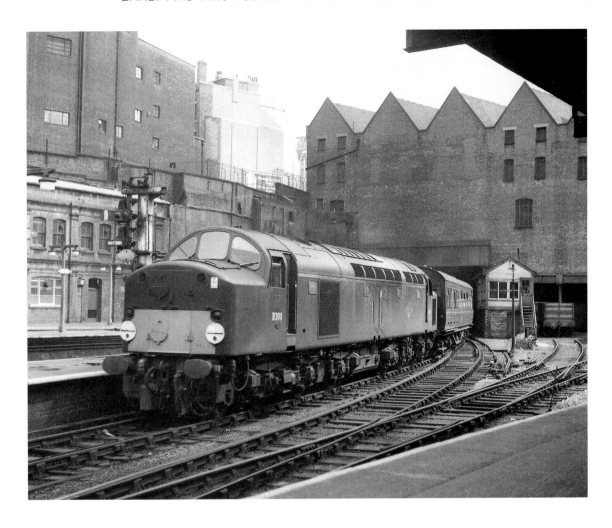

This spread shows examples of three classes of English Electric locomotives produced at two of their works.

Opposite top: **April 1962**. Vulcan Foundry-constructed Type 2 (Class 23) No. D5908 is seen entering Hornsey station with a 'down' local working. Entering service during 1959, it would be withdrawn ten years later in 1969. (Andrew Forsyth)

Opposite bottom: **April 1962**. Powering through Hornsey station at the head of the 'up' 'The Flying Scotsman' is Vulcan Foundry-constructed Type 5 (Class 55) No. D9018 *Ballymoss*. In sparkling condition, it had entered service only five months earlier and was based at Finsbury Park depot. It would be withdrawn twenty years later in 1981, numbered 55 018. (Andrew Forsyth)

Above: **Wednesday, 16 May 1962**. Arriving at Birmingham New Street station at the head of the 8.45 a.m. London Euston to Wolverhampton express is English Electric Type 4 (Class 40) No. D308, which was constructed at Robert Stephenson & Hawthorn Works. Entering service during 1960, it would be withdrawn in 1980, numbered 40 108. (Ron Buckley)

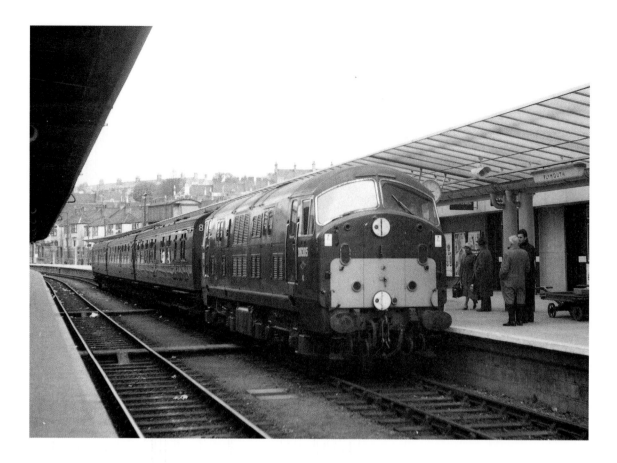

Above: **Saturday, 19 May 1962**. Waiting to depart from Plymouth North Road station, at the head of the 2.35 p.m. local working to Exeter St David's, is NBL-constructed Type 2 (Class 22) diesel hydraulic No. D6305. Entering service in early 1960, it would spend the bulk of its working life at Laira depot but be withdrawn after only eight years' service in 1968. (Ron Buckley)

Opposite top: **Wednesday, 23 May 1962**. Slowing for the stop at St Erth ('Change for St Ives'), the 'up' 'Cornish Riviera Express' has at its head NBL-constructed diesel hydraulic Type 4 (Class 43) No. D857 *Undaunted*. Entering service only five months previously, it had been allocated to Laira depot. Its working life was rather short, being withdrawn during 1971 after only nine years' service. (Ron Buckley)

Opposite bottom: **Saturday, 2 June 1962**. In Derby Works yard is the first of the ex-SR Ashford Works-constructed diesel electric main line locomotives. Entering service during 1950, No. 10201 would spend much of its time allocated to either Camden or Willesden depots and working on the London Midland Region. It would be withdrawn from service the following year, 1963. (Ron Buckley)

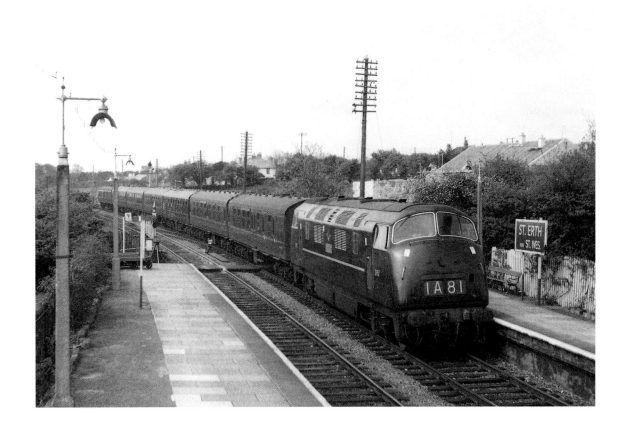

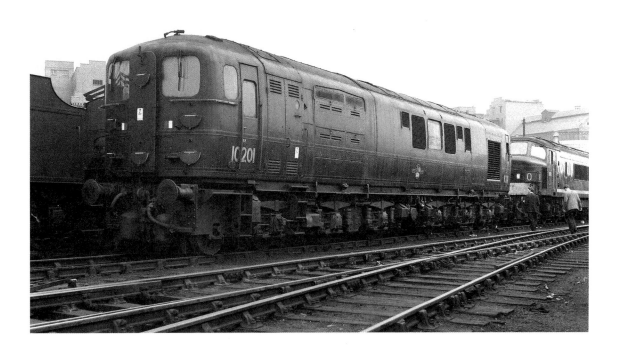

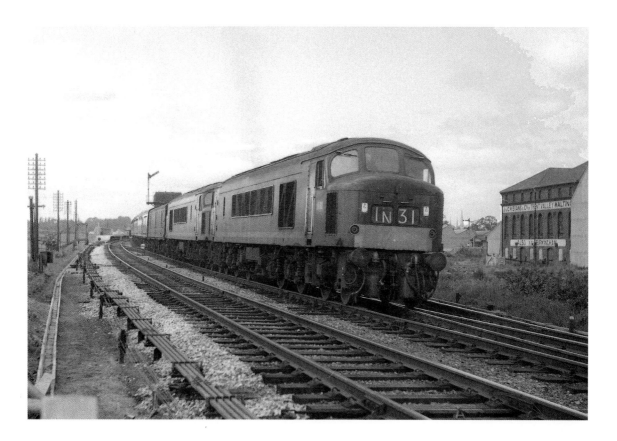

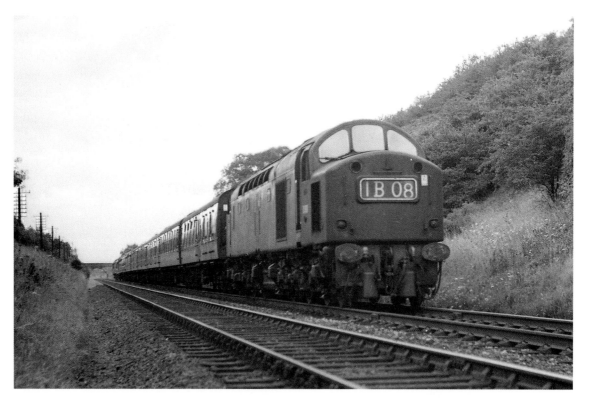

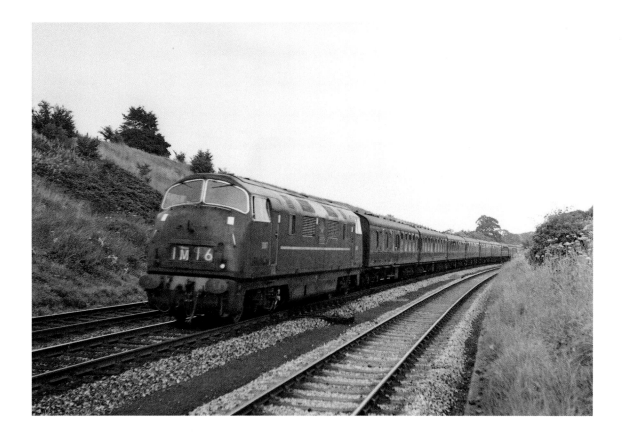

Opposite top: **Sunday, 24 June 1962**. Seen approaching Lichfield Trent Valley High Level station is the 10 a.m. Birmingham to Leeds passenger working. At its head are two BR/Sulzer Type 4 (Class 45) diesel electric locomotives, No. D62 piloting No. D67. Both examples entered service from Crewe Works early in 1962 and would be renumbered 45 143 and 45 118 respectively in the TOPS scheme. D62 would be named *5th Royal Iniskilling Dragoon Guards* in November 1964, with D67 becoming *Royal Artilleryman* during March 1966. Both would be withdrawn from service during May 1987, with *Royal Artilleryman* entering the preservation scene, having been bought privately. It is currently in store awaiting an overhaul. (Ron Buckley)

Opposite bottom: **Saturday, 25 August 1962**. Seen near Berkswell, south-east of Birmingham, English Electric Type 4 (Class 40) No. D369 is at the head of the 9.32 a.m. Wolverhampton High Level to London Euston passenger working. Constructed at the Vulcan Foundry during 1961, it would become No 40 169 in the TOPS scheme and be withdrawn in 1983. (Ron Buckley)

Above: **Saturday, 1 September 1962**. Swindon Works-constructed diesel hydraulic Type 4 (Class 42) No. D817 *Foxhound* is seen climbing Hatton Bank at the head of the 1.10 p.m. Paddington to Birkenhead working. Entering service during 1960, it would be withdrawn in 1971. (Ron Buckley)

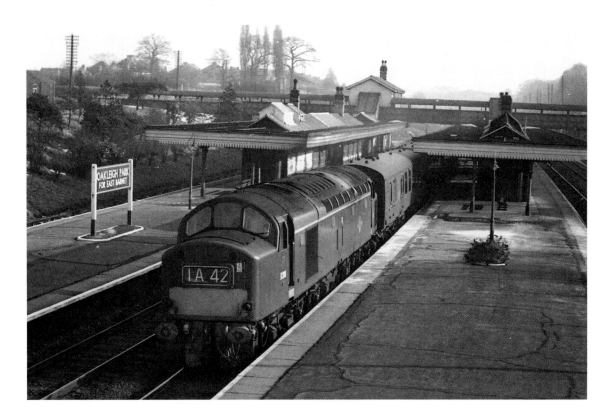

Above: **March 1963**. At the head of a 'down' working, English Electric Type 4 (Class 40) No. D388 is seen proceeding through Oakleigh Park station. Constructed at the Vulcan Foundry and entering service in 1962, it would be renumbered 40 188 in the TOPS scheme and be withdrawn twenty-one years later, during 1983. (Andrew Forsyth)

Opposite top: **March 1963**. Seen approaching Oakleigh Park station at the head of a local 'up' working is Brush Traction Type 2 (Class 30) No. D5681. Allocated new to Sheffield Darnall depot during 1961, by the time of this photograph it would be based at Finsbury Park depot. Re-engined during 1965, it would be reclassified Class 31 and renumbered 31 253 in the TOPS scheme. It would be withdrawn in 1995. (Andrew Forsyth)

Opposite bottom: **Monday, 25 March 1963**. Seen near Bethune Park, North London, at the head of an 'up' express is English Electric Type 4 (Class 40) No. D277. Entering service from the Vulcan Foundry during 1960, it would be allocated to both York and Gateshead depots throughout its working life. It would be withdrawn in 1983 numbered 40 077. (Hugh Ramsay)

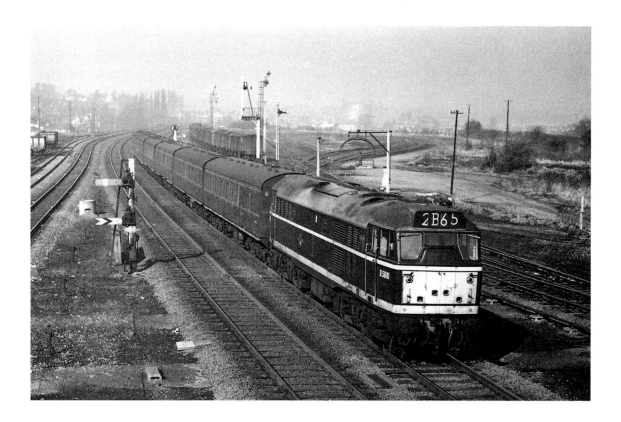

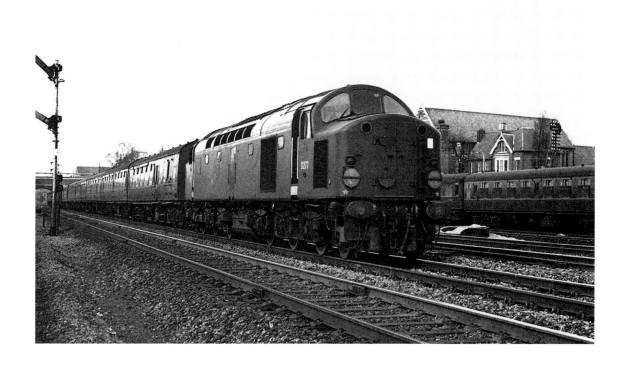

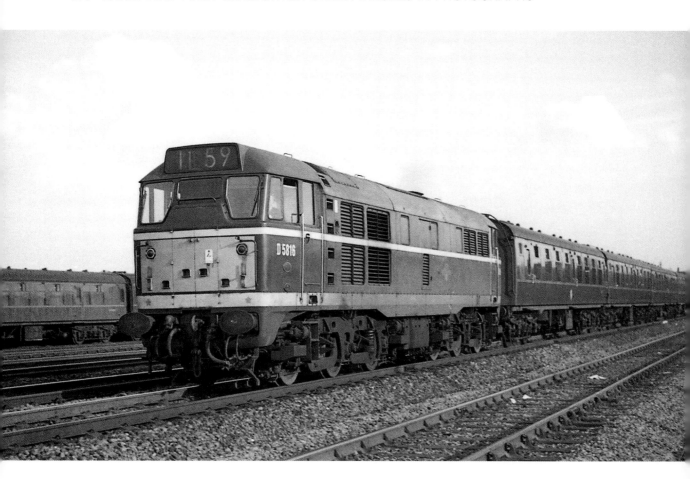

Thursday, 28 March 1963. In the North London suburbs near Bethune Park, Brush Traction Type 2 (Class 30) No. D5816 is working an 'up' train from Leeds. Entering service from its Loughborough Works in 1961, it would be re-engined during 1967 and reclassified Class 31. Numbered 31 284, it would be withdrawn from service in 1989. (Hugh Ramsay)

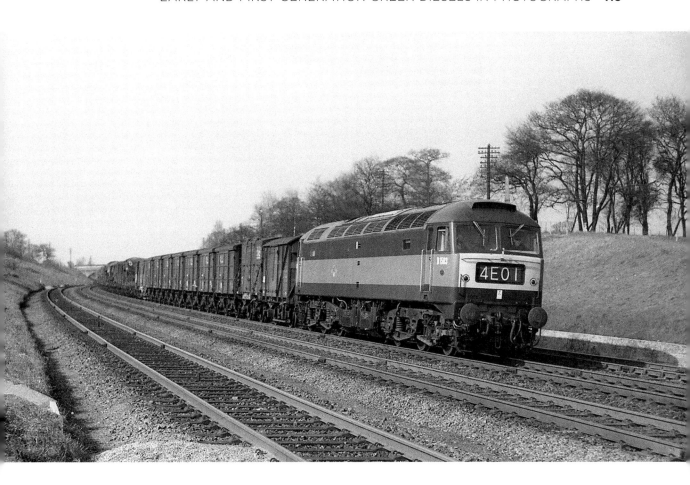

Friday, 12 April 1963. Barely four months old and still in good, clean condition, Brush Traction Type 4 (Class 47) No. D1503 entered service during November 1962. Seen here near Potters Bar in the 'up' direction working a long train of goods wagons, it would be numbered 47 404 in the TOPS scheme and be withdrawn during 1987. (Andrew Forsyth)

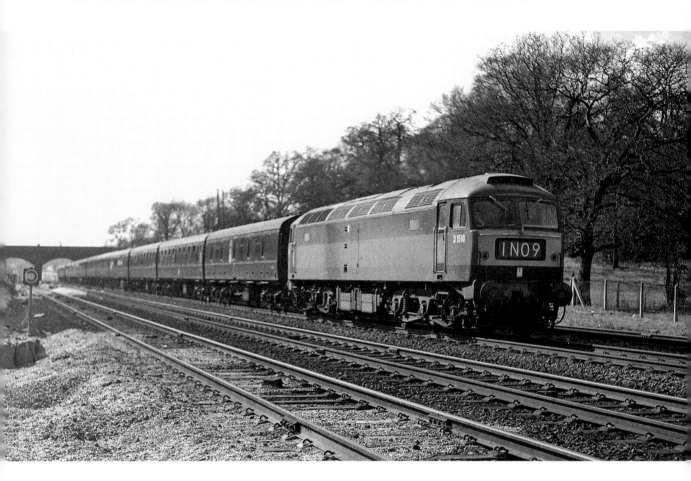

Friday, 12 April 1963. Brush Traction Type 4 (Class 47) No. D1510 is seen at the head of a 'down' express near the site of the former Greenwood signal box. Entering service two months earlier, it would be renumbered 47 411 before being withdrawn during 1989. (Andrew Forsyth)

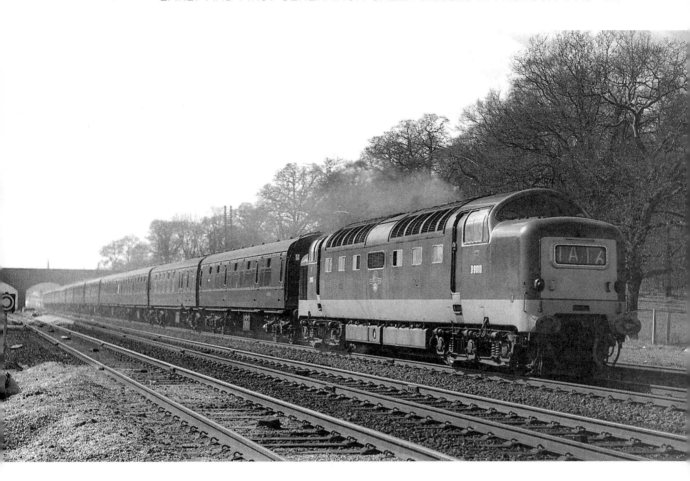

Friday, 12 April 1963. Also seen in the Greenwood area at the head of a 'down' passenger working is English Electric Type 5 (Class 55) No. D9010. Entering service during July 1961, it would be named *The King's Own Scottish Borderer* in May 1965 during a ceremony at Dumfries station. Allocated to Haymarket depot in Edinburgh for its entire working life, it would be withdrawn during 1981, numbered 55 010. (Andrew Forsyth)

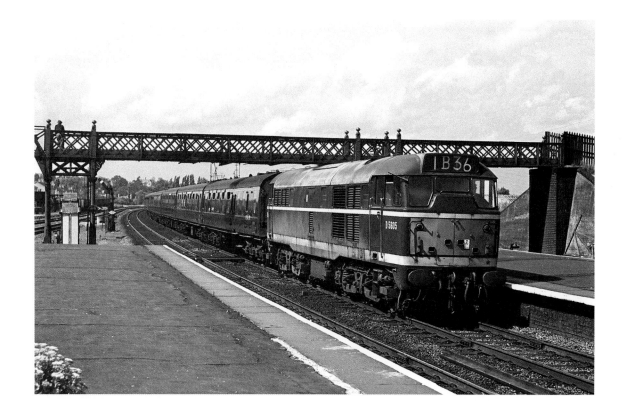

Friday, 12 April 1963. Brush Traction Type 2 (Class 30) No. D5605 is entering Oakleigh Park station at the head of an 'up' express. Constructed at Loughborough, it would enter service during 1960 before being re-engined in 1966 and reclassified Class 31. Numbered 31 404 under the TOPS scheme, it would be withdrawn during 1991. (Andrew Forsyth)

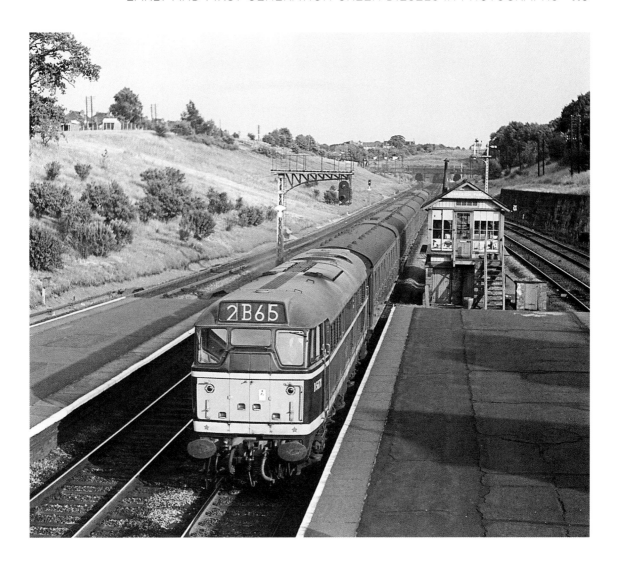

Friday, 12 April 1963. With Oakleigh Park station 'box at the end of the platform, Brush Traction Type 2 (Class 30) No. D5678 is seen approaching the station with a semi-fast working to Hitchin or Royston. Entering service during 1960, it would be re-engined in 1966 and reclassified Class 31. Numbered 31 250 in the TOPS scheme, it would give forty years of service before being withdrawn in 2000. (Andrew Forsyth)

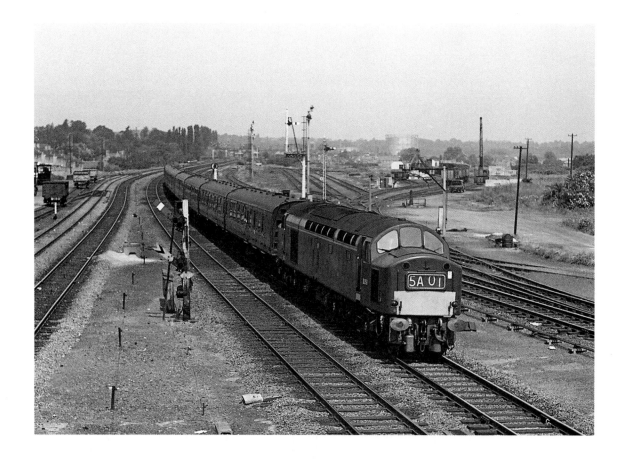

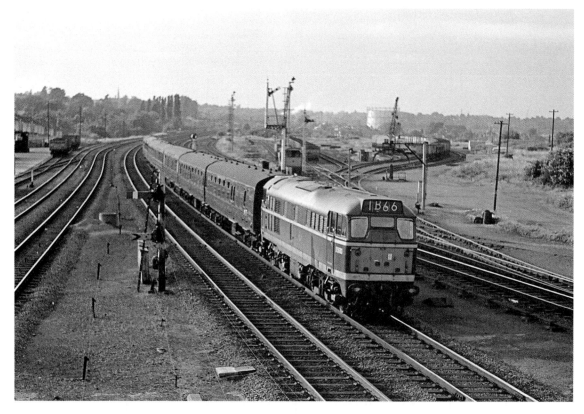

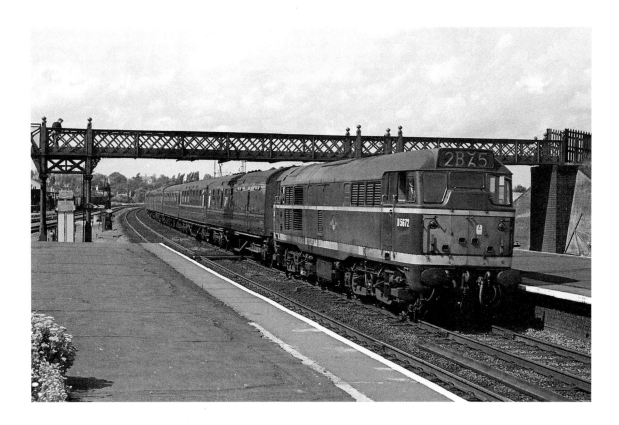

Opposite top: **Friday, 12 April 1963**. Seen on the approach to Oakleigh Park station, at the head of an 'up' train of empty coaching stock, is English Electric Type 4 (Class 40) No. D358. Entering service in 1961, it would remain based at Haymarket depot in Edinburgh until it was withdrawn during 1983, numbered 40 158. (Andrew Forsyth)

Opposite bottom: **Friday, 12 April 1963**. Also approaching Oakleigh Park station is Brush Traction Type 2 (Class 30) No. D5683 working an 'up' express. Constructed during 1961, it would be re-engined in 1966 and reclassified Class 31. Numbered 31 255 in the TOPS scheme, it would be withdrawn in 1988 but would find its way into the preservation scene. (Andrew Forsyth)

Above: **Friday, 12 April 1963**. On the approach to Oakleigh Park station, Brush Traction Type 2 (Class 30) No. D5672 is at the head of a local 'up' working. Entering service during 1960, it would be re-engined in 1968 and reclassified Class 31. It would later be numbered 31 244 before being withdrawn during 1983. (Andrew Forsyth)

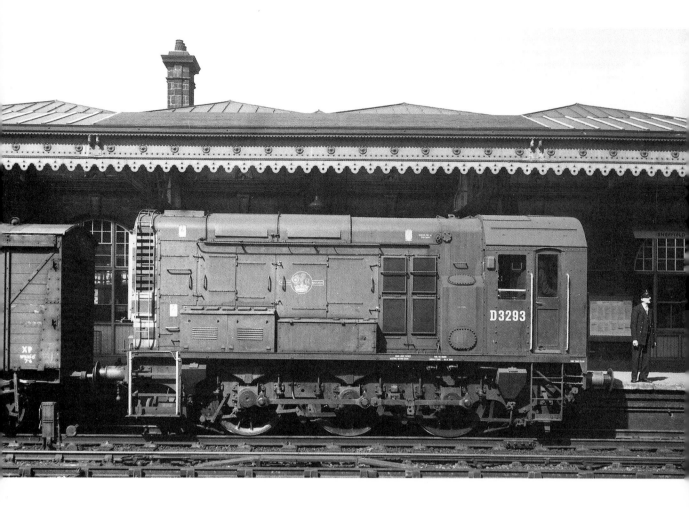

Above: **Saturday, 4 May 1963**. At Sheffield Midland the station pilot is 350hp 0-6-0 diesel electric shunter No. D3293. Constructed at Derby Works in 1956 and initially numbered 13293, it would become 08 223 in the TOPS scheme but be withdrawn during 1979. (Ron Buckley)

Opposite top: **Saturday, 20 July 1963**. The 2.30 p.m. Llandudno to Birmingham New Street via Walsall working is seen here near Brindley Heath in the hands of English Electric Type 4 (Class 40) No. D292. Entering service from the Vulcan Foundry during 1960, it would be withdrawn in 1982, numbered 40 092. (Ron Buckley)

Opposite Bottom: **Tuesday, 9 June 1964**. Seen approaching York station with a 'down' goods train is Brush Traction Type 4 (Class 47) No. D1557. Entering service from Crewe Works four months earlier, it would be numbered 47 441 in the TOPS scheme and be withdrawn during 1992. (Andrew Forsyth)

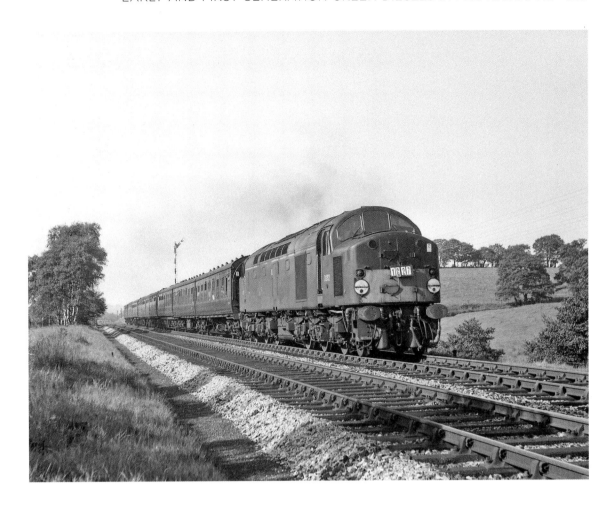

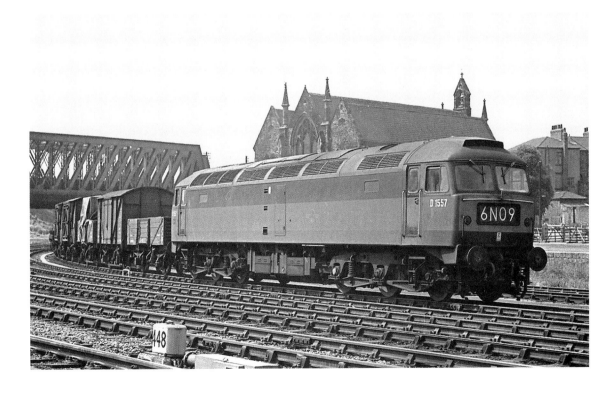

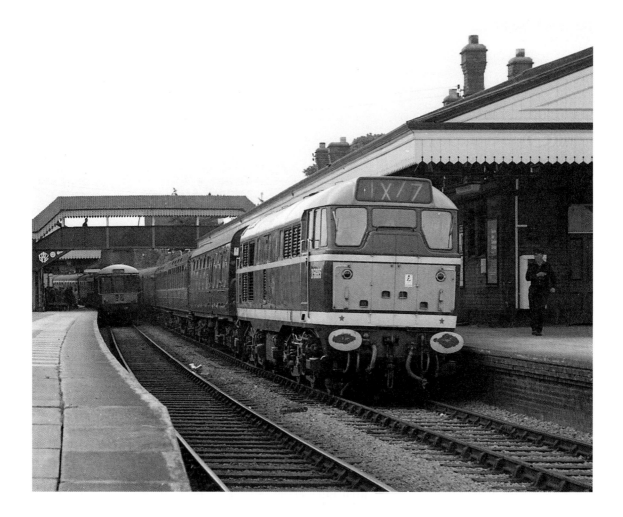

Thursday, 11 June 1964. In good, clean condition, Brush Traction Type 2 (Class 30) No. D5695 is seen at Stratford-upon-Avon station at the head of a special arrival from Bury St Edmunds. Entering service during 1961, it would be re-engined in 1968 and reclassified Class 31. It had a series of running numbers in the TOPS scheme – 31 265, 31 430 and 31 530 – it would eventually be purchased privately and is currently operational at the Spa Valley Railway. (Ron Buckley)

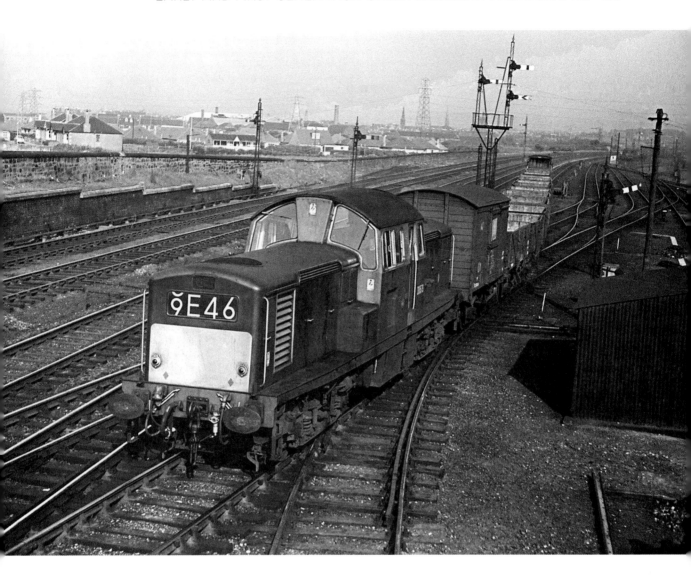

Monday, 15 June 1964. With the Craigentinny Carriage sidings in the background, Clayton Type 1 (Class 17) No. D8579 is working a short Class 9 unfitted goods train as it joins the westbound main line. Entering traffic three months earlier, it would be based at Haymarket depot in Edinburgh for the bulk of its working life, giving only seven years of service before being withdrawn during 1971. Fortunately, a single member of the class survived into the preservation scene, with No. D8568 being based at the Chinnor and Princes Risborough Railway. (Andrew Forsyth)

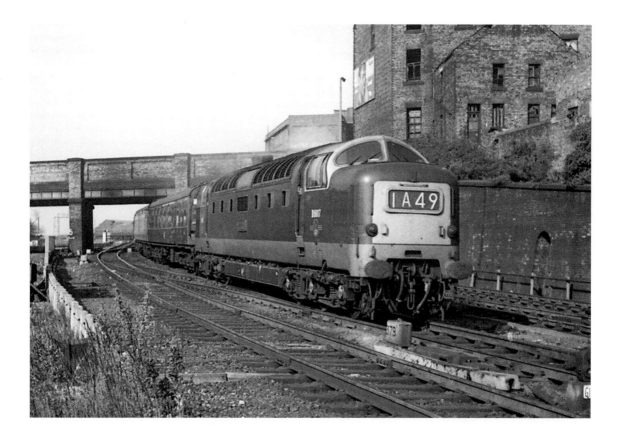

Above: **Thursday, 12 August 1965**. At the head of an 'up' express and seen departing from Newcastle, near the King Edward VII Bridge, is English Electric Type 5 (Class 55) No. D9017. Entering service during 1961, it would be based at Gateshead for its entire working life and be named *The Durham Light Infantry* in 1963. It would be numbered 55 017 in the TOPS scheme and be withdrawn from service in 1981. (Andrew Forsyth)

Opposite top: **Friday, 13 August 1965**. Beyer Peacock-constructed Clayton Type 1 (Class 17) No. D8599 is also seen near the King Edward VII Bridge in Newcastle with an 'up' goods train. Entering service in 1964, it would be withdrawn during 1971 after only seven years' service. (Andrew Forsyth)

Opposite bottom: **Friday, 13 August 1965**. Another Beyer Peacock-constructed Clayton Type 1 (Class 17), No. D8592 is seen here again near the King Edward VII Bridge, working an 'up' Class 9 unfitted goods train. Entering service in 1964, it would be withdrawn during 1971. (Andrew Forsyth)

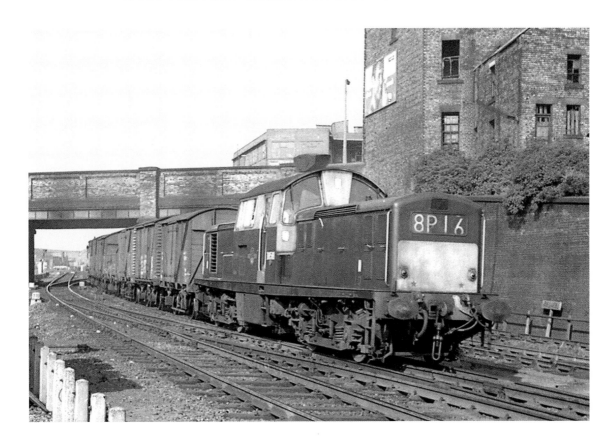

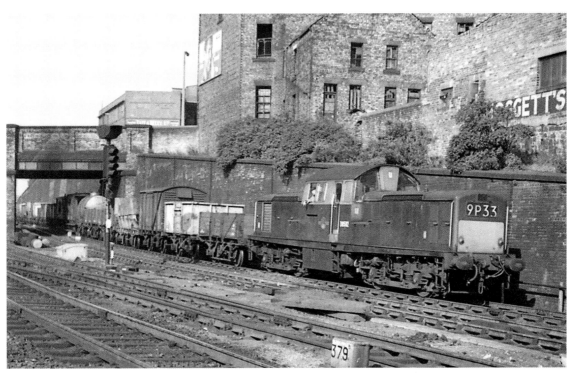

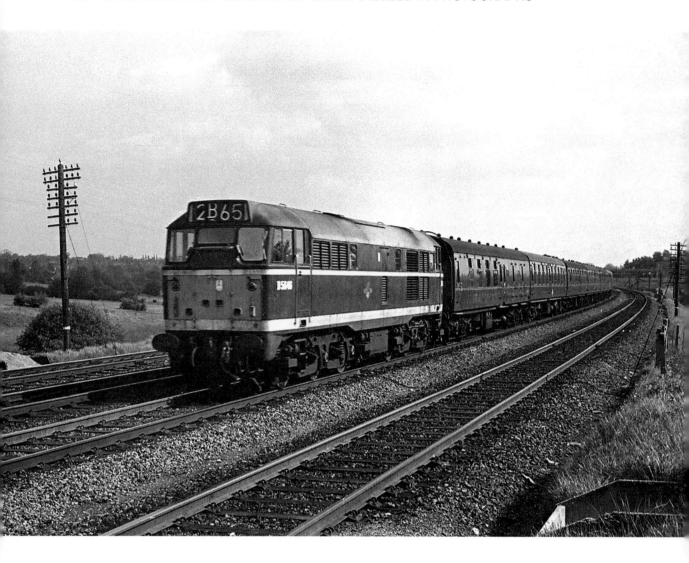

May 1966. Seen near Brookmans Park with a 'down' express is Brush Traction Type 2 (Class 30) No. D5646. Entering service in 1960, it would be re-engined during 1966 and reclassified Class 31. Numbered 31 408 in the TOPS scheme, it would be withdrawn in 1988. (Andrew Forsyth)